# John Moores
# Painting Prize
# 2010

Walker
Art Gallery

John Moores, about 1938

In 1957 John Moores (1896-1993) sponsored a competition for contemporary artists at Liverpool's Walker Art Gallery, with the intention of showcasing the best of new British painting.

The exhibition's main aims, stated in the first catalogue, were:

'To give Merseyside the chance to see an exhibition of painting and sculpture embracing the best and most vital work being done today throughout the country' and 'to encourage contemporary artists, particularly the young and progressive.'

The *John Moores Painting Prize* has since been held approximately every two years. It has become one of the most familiar events in the British art world and now forms one of the four main strands of the Liverpool Biennial.

This year brings the 26th exhibition since 1957, the *John Moores Painting Prize* 2010, and celebrates the first ever Chinese *John Moores Painting Prize* in Shanghai.

# Contents

# Foreword

The *John Moores Painting Prize*, launched in 1957, continues to be the UK's most prestigious painting prize. The £25,000 first prize and four other awards of £2,500 are certainly helpful to any artist, but more important still is the boost to reputation that winning the *John Moores* brings. Previous prizewinners include Richard Hamilton, Mary Martin, David Hockney, Michael Raedecker and Peter Doig, and the competition continues to be recognised amongst painters as the one to watch.

As always, this year's selection was based on the founding principles of the *John Moores:* to support artists and to bring to Liverpool the best of contemporary painting from across the UK. Throughout its history the *John Moores* has been supported by remarkable people and we are grateful to this year's judging panel for selecting another strong and interesting exhibition. We thank Gary Hume, Goshka Macuga, Ged Quinn, Sir Norman Rosenthal and Alison Watt for their focus and energy in selecting the prizewinners and exhibited artists. Our thanks go to Sir Norman Rosenthal, Ged Quinn and Alison Watt for their contributions to this catalogue. Jurors also generously shared their thoughts via audio-points in the

exhibition and on the National Museums Liverpool website: in an age of technology such access enables a larger number of people in both Liverpool and internationally to appreciate the quality of consideration involved.

Always held at the Walker Art Gallery in Liverpool, the *John Moores Painting Prize* is now launched internationally with its first overseas version. The *John Moores Painting Prize* in Shanghai has followed the same principles of anonymous entry, openness and careful selection by a jury of respected artists and curators. The Shanghai exhibition coincided with the Shanghai Expo and was held at Three on the Bund gallery in August. Happily the five Chinese prizewinners' paintings are displayed at the Walker Art Gallery alongside the UK exhibition. Lewis Biggs, Director of Liverpool Biennial and a juror in Shanghai, and Wang DaWei, Executive Dean of Shanghai University, Fine Arts College, have contributed essays to this catalogue about the significance of this international recognition. Ling Min, Director of Overseas Arts Projects, Shanghai University, Fine Arts College, has also played an important role in the smooth running of this project.

From the 1950s to today, the Moores family has been a driving force for the good of the exhibition and in support of artists. Special thanks are owed this year to James Moores for his role in China and Liverpool as well as to the members of the John Moores Liverpool Exhibition Trust and their Artistic Director Bev Bytheway. We would also like to thank the Trustees of National Museums Liverpool for their commitment and support and the many staff of National Museums Liverpool who have worked to make the show a success.

This year's *John Moores Painting Prize* exhibition of 45 works, selected from around 3,000 submitted, features paintings with subjects on contemporary themes in society as well as contemporary approaches to painting. Artists featured include established and emerging artists. We are delighted to present these works to you as a demonstration of the ongoing vitality and interest that painting holds today.

## Lady Grantchester
John Moores Liverpool Exhibition Trust

## Reyahn King
Director of Art Galleries,
National Museums Liverpool

# The jury

**Ged Quinn**
Artist

**Alison Watt**
Artist

**Gary Hume**
Artist

**Goshka Macuga**
Artist

**Sir Norman Rosenthal**
Freelance curator and writer

© Georgie Hopton

© Marcus Latham

## Gary Hume

Gary Hume was born in Kent in 1962. He lives and works in London and upstate New York, USA. His paintings are distinguished by a bright palette, reduced imagery and flat areas of seductive colour. He exhibited in *Freeze: Part II* and first received critical acclaim with a minimal, abstract body of work known as the *Door Paintings*. He was nominated for the *Turner Prize* (1996) and was a prizewinner in *John Moores 20*, 1997. His many solo shows include *Gary Hume*, Fundació "la Caixa", Barcelona (2000), *Carnival*, Kestnergesellschaft, Hannover (2004), *The Bird Has A Yellow Beak*, Kunsthaus Bregenz, Bregenz (2004), *Door Paintings*, Modern Art, Oxford (2004) and *Bird In A Fishtank*, Sprüth Magers, Berlin (2010).

## Alison Watt

Alison Watt was born in Greenock in 1965 and studied at Glasgow School of Art from 1983-88. In 2000 she became the youngest artist to be given a solo exhibition at the Scottish National Gallery of Modern Art and in 2003 she was shortlisted for the *Jerwood Painting Prize*. From 2006 to 2008 she was the Associate Artist at The National Gallery in London. Her subsequent solo exhibition *Phantom* (2008) explored her enthralment with one particular painting in their collection, Zurbaran's *'St Francis in Meditation'* (1635-9), and showed her fascination with the possibilities of the suggestive power of fabric. She was awarded an OBE in 2008.

## Ged Quinn

Ged Quinn was born in Liverpool in 1963. He studied at the Ruskin School of Drawing, Oxford, the Slade School of Fine Art, London, and the Kunstakademie, Dusseldorf. His absorbing, symbolic paintings draw upon historical art, referencing Baroque, Arcadian and Romantic landscape painting. His many solo shows include *Utopia Dystopia* at Tate St Ives (2004) and at Wilkinson Gallery, London *My Great Unhappiness Gives Me A Right To Your Benevolence* (2007) and *Somebody's Coming That Hates Us* (2010). His painting *There's a House in my Ghost* was exhibited in the *John Moores 25* exhibition in 2008. He also exhibited work at Tate Liverpool as part of the 2008 *Liverpool Biennial*.

© Dennis Schoenberg

© Phil Sayer 2000

## Goshka Macuga

## Sir Norman Rosenthal

Goshka Macuga was born in Poland in 1967 and lives and works in London. She studied at Wojciech Gerson School of Art, Warsaw and in London at Central Saint Martins School of Art and Goldsmiths College. She combines the roles of collector, curator and artist in her mixed media installations. In 2008 she was nominated for the *Turner Prize* following her exhibition *Objects* in *Relation: Art Now* at Tate Britain (2007). She has exhibited at Biennales in São Paulo (2006), Liverpool (2006), Berlin (2008) and Venice (2009). Recently her exhibition *The Nature of the Beast* was at London's Whitechapel Gallery (2010).

Sir Norman Rosenthal was born in Cambridge in 1944 and is a freelance curator and writer. He became Exhibitions Secretary of the Royal Academy of Arts, London in 1977, where he stayed for 30 years, overseeing loan exhibitions and working with distinguished curators. At the Martin Gropius-Bau, the leading exhibition venue in Berlin, he was co-responsible for two ground-breaking contemporary art exhibitions, *Zeitgeist* (1982) and *Metropolis* (1991), as well as *The Age of Modernism - Art in the 20th Century* (1997). He received a knighthood in 2007 and has also been awarded honours from the Italian Republic, Federal Republic of Germany, French Republic and the Federal Republic of Mexico. In 2009 he contributed an essay to the

Anish Kapoor exhibition catalogue which was written to accompany the artist's show at the Royal Academy. In the same year his 'In Conversation' with the celebrated artist Jeff Koons was a fascinating highlight of *Art 40 Basel*.

# The judging of the John Moores Painting Prize 2010

## Sir Norman Rosenthal

The judging of an open submission painting competition for a prestigious exhibition is, to put it mildly, a very funny business. The *John Moores* is surely the best known and most prestigious painting prize in Great Britain. Back in the '60s and '70s when I was young, there was no doubt that if, as a young painter, you won the Prize, you had in a real sense arrived. I certainly felt very flattered to be invited to be a judge this year, particularly as the only non-artist on the panel of very distinguished practitioners, including my dear friend Gary Hume. It was an opportunity too to get to know three other wonderful creative individuals; Goshka Macuga, Alison Watt and Ged Quinn. Once we got together for the final judging session over a period of two days, we all bonded beautifully.

Nonetheless, the process as a whole was quite strange for me, and reminded me in the end of nothing so much as that which I had observed over decades at the Royal Academy as the Academicians sit choosing *Summer Exhibition* after *Summer Exhibition*, each one ending up looking very much like the last. When I worked at the Royal Academy it was one thing I consciously steered away from, never wanting to get involved in the politics and

horse-trading that was the inevitability after wading through thousands of hopeful submissions from all over the country. Somehow, I didn't expect the *John Moores* to be quite like that, but in fact there are similarities, and the general level of submissions is not unlike. The only difference is that this is the age of the 'Cloud' - I mean the internet - and trying to judge seriously, in the privacy of your own home, over 3,000 images by 3,000 hopefuls in the initial 'sift-through' of images was quite an experience. It had an alienating aspect to it, taking literally 12 hours and more!

For me, as a non-artist, art, and painting in particular, has many 'mansions' in possibilities of style and execution. Appreciation and enjoyment has a lot to do with recognition on the one hand, and surprise on the other. The great disadvantage is not having the actual painting in front of one, because of course, texture is everything. You can perhaps check the size to get a sense of scale, but the former is impossible to judge without the real thing. But it was clear to me, and I think to my fellow jurors operating to begin with in isolation from each other, that there were inevitably lots of works which, even if well intended,

were somehow, frankly speaking, 'amateur'. Yet this is surely a prize about professionalism and achievement. There were an awful lot of dogs, cats and little birds, views of Venice and the like, though there is nothing inherently wrong with that as such. Which is not to say that the recognition process is flawless - far from it. In a few cases of course, as someone who lives in the wonderful world of art, I did actually recognise the artist - or at least I thought I did. In one particular case, I most definitely thought I did, but seem to have got it wrong. Is the artist who got through a *pasticheur*, or are they just as good as the guy who I think submitted, but somehow didn't get through?

Chance too will have its way, and just as the jury was due to convene in London to discuss which paintings would be called to Liverpool for the final selection, myself and one of my co-judges found ourselves stuck on the other side of the Atlantic thanks to another 'cloud', the volcanic one. As a result we had to do the next stage of selection independently by computer once again, with all the aspects of chance that this clearly brings to the process. In this sense, open competitions are a little bit like architectural competitions. I can think of at least one classic prestigious building in Paris where the judges thought they were picking a famous architect, indeed, the design looked completely like. But when the envelope was opened, it turned out to be somebody different. I speak here of the Opera House at the Bastille! And of course, it all went ahead and I suppose the unknown architect's career was made as a result.

At least we all had our last round together in Liverpool looking at some 300 works in their reality. On the whole there was very little argument as to what made the final cut of 45 paintings. Somehow, in a very eclectic world of cultural possibilities in the field of painting, that elusive and difficult to define thing called quality did reveal itself. The possibilities of both abstraction and figurative painting are bottomless. One might have wished that more 'well-known' painters had submitted, but it is good too that through the prestige of the Prize, certain unknown, or at least little-known artists have a chance to come into the spotlight. Possibly, through the competition, they will develop their careers and the recognition factor in their work will grow a bit further.

After all, art is about recognition and familiarity, and the opportunity for the judges and the audience to engage with new and unfamiliar work, and for it to become familiar through the mechanism of the competition, is wonderful. The world of art is, in that sense, like one big elective family. A lot of people accuse it of being an elite. It is indeed an elite family, but it is an elite family that anyone with something to give can join as an artist or in other ways, including as a regular and informed viewer. The *John Moores Painting Prize* is just one more marvellous incremental way of becoming part of that family of art that extends through place and time, through geography and history, giving us all a chance of leaving behind traces that might at least to some extent live after us. Just think of some of the amazing painters who have won *John Moores* first prizes in the past; Patrick Heron, Roger Hilton, David Hockney, Richard Hamilton, John Hoyland (all those H's!), Euan Uglow, Mick Moon, Lisa Milroy, Peter Doig, Peter Davies. All these and more are artists who through their painting leave beautiful traces in our culture and who surely will never be written out of the history of British and even in some cases, the international art of our time. I suspect that amongst the 45 artists who have made the cut this time, there are two or three who might make it into this elite.

Selection at every level is a cruel business, or as Charles Darwin says: 'As many more individuals of each species are born than can possibly survive; and as, consequently, there is a frequently recurring struggle for existence, it follows that any being, if it vary however slightly in any manner profitable to itself, under the complex and sometimes varying conditions of life, will have a better chance of surviving, and thus be naturally selected.' This is true of the cultural process as well, but there is always a chance, even a very good chance, that the judges themselves might be wrong and that something quite different will arise and survive from the mass of submissions to the *John Moores Painting Prize* 2010.

Nonetheless, the judges all congratulate, with confidence, this year's selected artists and prizewinners.

Norman Rosenthal, June 2010

# Premium Selection

## By Ged Quinn

The philosopher Gilles Deleuze thought Francis Bacon had a problem. Not that it was just Bacon's problem, but one shared by all painters - that the blank canvas on which they paint is not really blank at all. It is already full of images that bring with them a host of cultural associations, a myriad of trite symbols, well-worn narratives and ready-made meanings.

Deleuze's proposition came to mind when considering the works submitted for the *John Moores Painting Prize* exhibition. What can lie outside of legitimate consideration? Dreams, visions, error, intoxication, cruelty, misperception? The artistic urge to escape the clichés of illustration and narration through the primitive, modern, postmodern... the judging process was intense. To critically assess any work 'blind', in a manner that FR Leavis, the early 20th century literary critic, had propounded, could appear, at first blush, to be one of joyous simplicity. But the critical act of viewing without cultural, historical or social context was, for me, fraught. The peel of the Barthesian bells, proclaiming the death of authorial intention, rang a little hollow as my desire to know more about each work (other than what appeared on canvas) grew. The resulting process required a rigour and concentration, and to some extent, a faith, that astounded me.

The works acquired as a result of the past 53 years of the *John Moores* exhibition are an exceptional addition to the Walker Art Gallery's collection. The purchase of art is always under threat in financially challenging times but its value is incalculable. That we could be choosing a work or works which could join the fantastic collection of the Walker was something that was particularly pertinent to me. Since childhood I have visited the Gallery more times than I can remember but the nature of the experience I can always recall. For instance, my first time in the Renaissance gallery, being captivated by the Ercole de Roberti *Pieta*, and other beautiful works, so small, with a patient, devotional intensity I had not found in the cinematic dramas of the brooding Victorian history paintings in some of the other galleries.

Dominating the stairs I remember Solomon's *Samson*, an academically rendered Bible story in high-definition, more hyper-muscular than Superman. Something about the perpetual wintry sadness of Delaroche's *Napoleon crossing the Alps* also remains with me.

At the time, perhaps the Gallery's most popular work was Yeames' little boy in blue in front of his Parliamentarian inquisitors. What a great name for a painting: *And when did you last see your father?* 'Romantic innocence' painted in 1878 in an increasingly industrialised and urbanised society. The implications and potential interpretations are so much wider than an initial view of the work could lead one to think. I was unaware of the history upon which it was based and nobody was interested enough to explain, even if they knew. You are led into the painting by an intriguing fragmentary quotation, a shred of a narrative, its available readings altering as the work's quietness travels through time and outlives its audiences.

Going back to Deleuze; he wrote that art is a means by which we confront chaos. Art commences in chaos and provides a means by which we pass through it, not necessarily a rationalising process provided by science or philosophy, but a way of creating the 'possible'. A work of art does not actualise the event but 'incorporates or incarnates it: the work of art gives it a body, a life, a universe...'

# There's no telling what we might find...

## By Alison Watt

There is something about painting. It is unique as a medium, because there are certain things that only painting can do. The hard part is trying to describe them.

We read the surface of a painting hoping that it will tell us the story of how it was made; its physicality affecting our understanding of it. But trying to explain one language in terms of another is fraught with difficulty. When asked what a piece of his music meant, Robert Schumann played it again. In many ways painting defies description. It has to be experienced. It isn't only about how something looks but rather what you feel when you see it. And it's a feeling that can't be replicated by any other means. When you look at a painting for a long time, ideas will begin to form that are not based on what you can see; it will often suggest something other than itself. It's a process that can be incredibly demanding and a truly great picture will never reveal itself all at once. Perhaps it's what you don't understand that continues to attract you, but if you're really lucky, it might make you consider what it's like to be in the world. In truth, you can really only guess what painting is about.

There's an essay by Thomas Hess on Barnett Newman which I was given years ago. This extract sums up for me the 'problem' with painting. I've always loved it.

*Franz Kline and Elaine de Kooning were sitting at the Cedar Bar when a collector Franz knew came up to them in a state of fury. He had just come from [Barnett] Newman's first one-man show. ' How simple can an artist be and get away with it?' he spluttered. 'There was nothing, absolutely nothing there!'*
*'Nothing?' asked Franz, beaming. 'How many canvases were in the show?'*
*'Oh maybe ten or twelve - but all exactly the same - just one stripe down the center, that's all!'*
*'All the same size?' Franz asked.*
*'Well no; there were different sizes; you know, from about three to seven feet.'*
*'Oh, three to seven feet, I see; and all the same color?' Franz went on.*
*'No, different colors, you know; red and yellow and green ... but each picture painted one flat color - you know, like a house painter would do it, and then this stripe down the center.'*
*'All the stripes the same color?'*
*'No'*
*'Were they all the same width?'*

*The man began to think a little. 'Let's see. No. I guess not. Some were maybe an inch wide and some maybe four inches, and some in between.'*
*'And all upright pictures?'*
*'Oh, no, there were some horizontals.'*
*'With vertical stripes?'*
*'Oh, no, I think there were some horizontal stripes, maybe.'*
*'And were the stripes darker or lighter than the background?'*
*'Well I guess they were darker, but there was one white stripe, or maybe more...'*
*'Was the stripe painted on top of the background color or was the background color painted around the stripe?'*
*The man began to get a bit uneasy. 'I'm not sure,' he said, 'I think it might have been done either way, or both ways, maybe ... '*
*'Well I don't know,' said Franz. 'It all sounds damned complicated to me.'*

(Thomas Hess in *'Barnett Newman'*, 1972, © Tate)

# First prizewinner
# £25,000

# Keith Coventry

# Keith Coventry

## Spectrum Jesus

2009
Oil on canvas, wood and glass
68.6 x 58 cm

Keith Coventry creates paintings and sculptures which manipulate legacies of Modernism to address conditions of contemporary urban life. His work demonstrates an enduring interest in the dark flipside of idealism: urban decay, social failure, drug abuse and alienation. Many of the art historical references that Coventry deploys are defined by the Utopian ideals of Modernism, the aim of which was to refashion the world. He plays with these beliefs and shows them to be misplaced, even misconceived, the gulf between belief and reality stimulating a series of troubling undercurrents in the work.

Coventry's idiosyncratic and personal project to create a form of contemporary history painting encompasses an immense range of references. His paintings and sculptures pit art history - Malevich, Rodchenko, Dufy, Morandi, Sickert, International Modernism, Minimalism and Pop Art - against images of heroism and idealism, and dissolute decadence and aberrant behaviour. Coventry's subjects range from the racism of the football terraces to the commodity status of the artwork, from the perfection of the proportions of a supermodel's face to the degradation of the crack den.

## Biography

Keith Coventry was born in Burnley in 1958 and lives and works in London. He attended Brighton Polytechnic 1978-81 and Chelsea School of Art London 1981-82. He featured in *Sensation* Royal Academy of Arts London 1997. Solo exhibitions include *Ivory Towers* 1992, *Suprematist Paintings I – X* 1993, *White Abstracts* 1994, all at Karsten Schubert London, *Paintings* Tramway Glasgow 2006, *Key Groups* Julius Werner Gallery Berlin 2007. Recent solos include *Painting & Sculpture, Part I: Early Groups* Haunch of Venison London/Seomi & Tuus Seoul Korea 2008 and *Paintings and Sculptures Part II: Works 2002-2009* Haunch of Venison 2009. Exhibited in *John Moores 21* 1999.

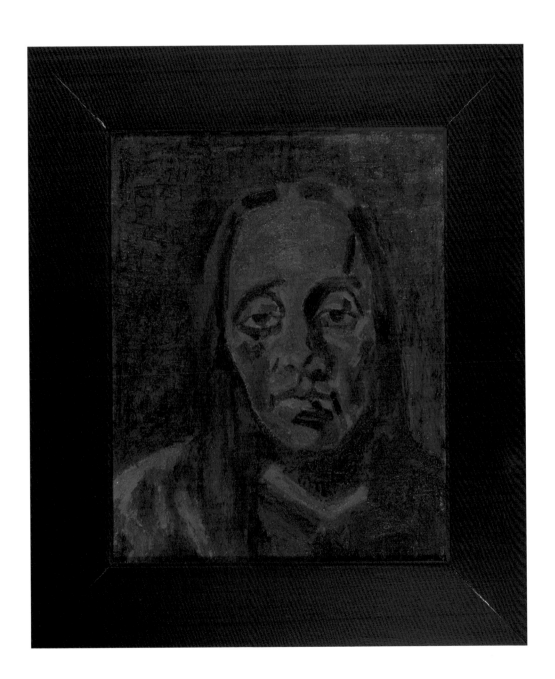

Keith Coventry

# Prizewinners
# £2,500

**Philip Diggle**
**Nick Fox**
**Nicholas Middleton**
**Daniel Sturgis**

# Philip Diggle

## For Your Pleasure

2009
Oil on canvas
92 x 75 cm

it's talking time for the moon boys
sitting in the rose garden
rolling in the hay
between the devil and the deep blue sea
against the Machiavellians
against the golden calf of realism

Thank you (falettinme be mice elf agin)

## Biography

Manchester-born Philip Diggle studied Art History at London's Chelsea School of Art. Exhibitions and performances include *There Was an Old Lady Who Swallowed a Fly* The Original Gallery London 2008, *I IS SOMEONE ELSE: Soho Review* The Assembly Rooms London 2009, *Polyphiloprogenitive* The Pad Bedford 2010. *The Camden Chronicles* 2010 documents his artistic journey and early '80s life in Royal College Street, Camden, reflecting his Sartrean, existential thoughts. The poets Verlaine and Rimbaud lived in the same street. *Exile 498* (film by Eddie Otchere) previews live Paris, Berlin Sept/Oct 2010. Critic Clement Greenberg remarked of Diggle's work, "You sure can paint an ugly image."

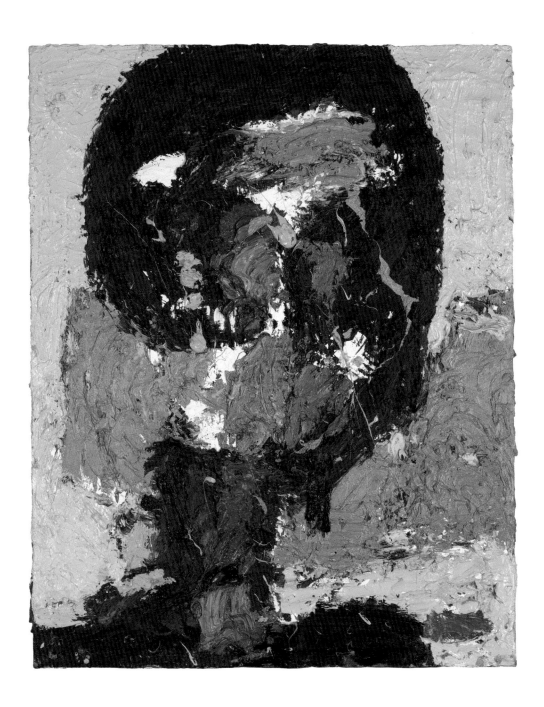

Philip Diggle

# Nick Fox

## Metatopia

2009
Acrylic and ink on panel
120 x 120 cm

Behind the reflective surfaces of my mirrored paintings hide a labyrinth of disparate and sometimes conflicting meanings, 'a rubble of distinct and unrelated signifiers', simultaneously clear and elusive. My paintings are camouflaged as decorative objects or planes of uninflected colour. They draw upon Neoclassicism, Victorian visual culture and sub-cultural symbology to reveal imagery from contemporary pornography that defies the viewer's initial expectation of an encounter with such seductive objects.

*Metatopia* is part of a series of works inspired by floriography, the Victorian cultural phenomenon which used flowers as tokens of romantic longing, commitment or rejection to communicate hidden or forbidden pleasures. I am drawn to the intensification of desire that comes with secrecy and taboo, and playfully invert and personalise the artifice of this *fin de siècle* language to create elusive narratives and unsustainable utopias.

The mirror-like polished panels are carefully built up over periods of up to 18 months, through a lengthy process of layering of vaporous acrylic colour with erotic and floral drawings. These idylls are often rendered in dark and muddy colours that, along with my painting process, create a toxic fog, an Eden after the Fall, one where innocence has been banished.

(From *'Postmodernism or The Cultural Logic of Late Capitalism'* by Frederic Jameson, 1991)

## Biography

Born in South Africa in 1972, Nick Fox attended Liverpool John Moores University 1992-95 and the Royal Academy Schools London 1998-2001. He lectures at Newcastle University. Exhibitions include *Vanitas* (curator Max Presneill) Raid Projects Los Angeles 2003, and in London *This Longing* The Drawing Gallery 2006, *Jerwood Contemporary Painters* Jerwood Space 2007, *Salon 2007: New British Painting* (curator Flora Fairbairn) 319 Portobello Road. Solo projects include *Unveiled* (with Francis Picabia) MOCA London 2006, *Phantasieblume* C4RD London 2009 and Vane Gallery Newcastle 2010. His 2009/10 residency at Sunderland's National Glass Centre developed *The Longing Archive*, exploring longing, loss and unrequited desire.

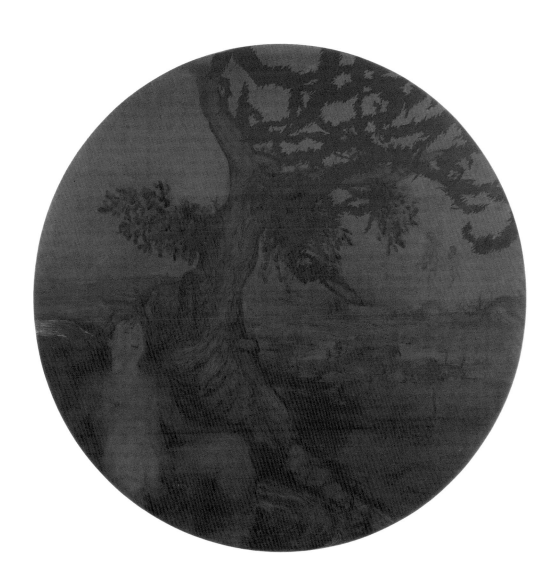

Nick Fox

# Nicholas Middleton

## Protest, 1st April 2009

2010
Oil on canvas
117 x 203.5 cm

Timed to coincide with the G20 summit of industrialized nations on 1st April 2009, 5,000-6,000[1] people demonstrated in London at a number of locations over various issues. This painting depicts the Financial Fools' Day protest outside the Bank of England.

**Bank of England Special Liquidity Scheme** extended by £100bn in October 2008, £185bn lent by February 2009[2]; **Credit Guarantee Scheme** £250bn; £91.2bn guaranteed by May 2009[3]; **Northern Rock** cost of nationalization: £26.9bn[4]; **Bradford & Bingley** cost of nationalization: £48bn[5]; **Lloyds Banking Group** 43%[6] publicly owned at a cost of £21bn[7]; **Royal Bank of Scotland** 70%[8] publicly owned at a cost of £31.8bn[9]

The measures taken to prevent the banking system from collapsing have added an estimated £1tn[10] to public sector debt. This equates to **£16,000** per person in the UK.[11]

[1] Home Office briefing prepared for the Chancellor of the Exchequer, 02/04/09. Released through FOI request, retrieved from http://www.blowe.org.uk/2009/10/home-office-foi-release-on-g20-protests.html 12/05/10. [2] *Public Sector Interventions in the Financial Crisis*, Kellaway, Martin, the Office for National Statistics 2009, p81. [3] Ibid, p108. [4] Ibid, p32. [5] Ibid, p44. [6] *UK Financial Investments Annual Report 2008-09*, UKFI 2009, p2. [7] Kellaway, Martin, op cit, pp75-77. [8] UKFI, op cit, p2. [9] Kellaway, Martin, op cit, pp 68-69. [10] Ibid, p 79. [11] Based on UK population of 61,414,062, World Development Indicators, World Bank 2008.

## Biography

Nicholas Middleton was born in London in 1975. He studied at London Guildhall University 1993-94 and Winchester School of Art 1994-97. His exhibitions include *Defining the Times* Milton Keynes Gallery 2000, *BP Portrait Award 2004 and 2005* National Portrait Gallery London and the solo show *Black & White Paintings* Arch Gallery London 2010. He was shortlisted for the BOC Emerging Artist Award in 2002 and has shown seven times in the *Summer Exhibition* at the Royal Academy of Arts London. He was included in *John Moores 23* 2004, and won the Visitors' Choice Prize in *John Moores 24* 2006.

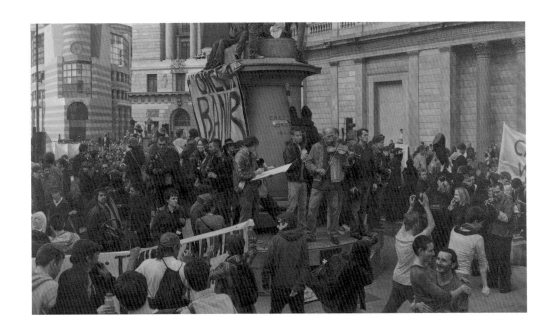

Nicholas Middleton

# Daniel Sturgis

## Still Squallings

2009
Acrylic on canvas
138 x 213.6 cm

Within the painting, seemingly divergent positions are in agreement, reconciled or able to exist politely together. There is balance, as differing references from art, contemporary culture, abstraction and design are brought together to share common ground.

## Biography

Daniel Sturgis was born in London in 1966. He studied at Camberwell College of Arts London 1986-89 and Goldsmiths College London 1992-94. His solo exhibitions include *Everybody Loves Somebody* The Locker Plant Chinati Foundation Marfa Texas 2007, *Possibilities in Geometric Abstraction* Galerie Hollenbach Stuttgart 2008 and *Conversation Pieces* The Apartment Athens 2010. Recent group exhibitions include *Plastic Culture*: Legacies of Pop 1987-2008 Harris Museum and Art Gallery Preston 2009, *Invisible Cities* Jerwood Space London 2009 and *Superabundant: A Celebration of Pattern* Turner Contemporary Project Space Margate 2009. He exhibited in *John Moores 23* 2004.

Daniel Sturgis

# Exhibiting artists

Cornelia Baltes
Jon Braley
G L Brierley
Deborah Burnstone
Darren Coffield
Edward Coyle
Theo Cuff
Stuart Cumberland
Ian Davenport
Tim Ellis
Geraint Evans
Adam Fearon
Damien Flood
David Fulford
Mikey Georgeson
Chris Hamer
Andy Harper
Richard Harrison
Sigrid Holmwood
Phil Illingworth

Lee Johnson
Neal Jones
Joseph Long
Elizabeth McDonald
Michael Miller
Matthew Mounsey
Jost Münster
Cara Nahaul
Narbi Price
Steve Proudfoot
Sabrina Shah
Annabelle Shelton
George Sherlock
Michael Simpson
Henrietta Simson
Veronica Smirnoff
Ian Peter Smith
Geraldine Swayne
Jason Thompson
Christian Ward

# Cornelia Baltes

## THERE YOU ARE!

2010
Acrylic on canvas and wall
310 x 220 cm

The general source of my work is the observation of daily life. I try to point out small things that touch me and create paintings that combine simplicity with a sense of humour. My relationship with painting is rooted in its potential for energy and gesture which offers me a directness not found in another medium.

I want my paintings to be enjoyable to look at.

I want the viewer to catch my idea of beauty - hidden in simplicity - in a small gesture, in bright colour, through capturing the essence of an easy idea.

My painting *THERE YOU ARE!* reveals a turning point in my recent work. I was questioning the depiction of figures in my paintings with this big abstract painting on canvas. The idea of the finger appeared suddenly. By adding this finger on the wall, it demanded that I looked at my painting anew. Then I discovered that I had completed my work. The viewer gets involved in an action by responding to the sign as if to obey. On the other hand the viewer remains outside the painting, simply an observer.

I called this picture *THERE YOU ARE!* because with this spontaneous gesture of painting the finger, I felt I had somehow provided an answer to my enquiry.

## Biography

Cornelia Baltes was born in Moenchengladbach, Germany in 1978. She studied at the University of Wuppertal 2000-03, the Folkwang University of Art Essen 2003-06 and attended the Pentiment Summer Academy Hamburg (scholarship holder) 2006. She is currently undertaking postgraduate study at The Slade School of Fine Art London 2009-11. Selected group exhibitions include *Außenstelle No.2* Forum for Art and Architecture Essen 2005, *Chez Nous* Kunsthaus Essen 2007, *Love Stories* GAM Galerie am Museum Essen 2007, *Die Große Kunstausstellung NRW Düsseldorf* Stiftung Museum Kunst Palast Düsseldorf 2008 and *EXHIBITIONISM:The Art of Display* The Courtauld Institute of Art London 2010.

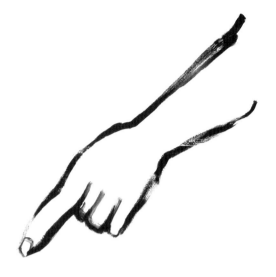

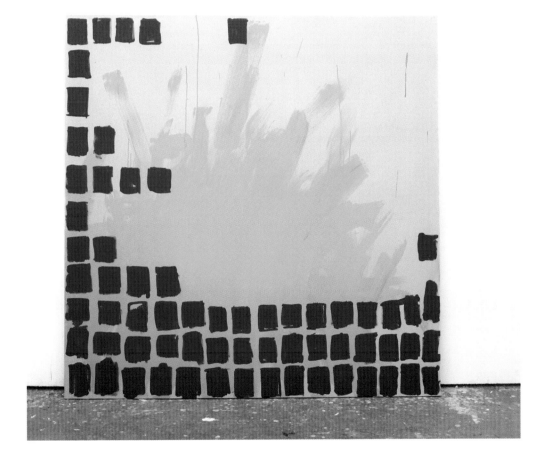

Cornelia Baltes

# Jon Braley

## Untitled

2009
Mixed paint and resin on canvas
91.2 x 121.5 cm

My paintings are all about how we relate to nature in an urban, technological age.
The more we live in cities and cocoon ourselves from the natural world, the more we
become separated from it. It has almost become a commodity, something that we have
come to see as separate from ourselves.

I look to examine nature not as a pretty scene (as in traditional landscape painting),
but as an intangible, isolated other, a concept or raw energy rather than something
defined and solid. There are hints of horizon lines and figurative suggestions - this blue
painting might remind one person of the sea, another of smoke from a fire, or the depths
of a forest - but the objective is to use abstraction to tap into something more amorphous
and primeval. This is rooted in my painting process. I paint with my hands and tools
rather than using brushes, working the paint in an almost trance-like state to create
something sublime, organic and fluid. But at the final stage, I seal the works in resin,
creating a physical barrier between the viewer and the abstract natural ideal that in
some way reflects our state of separation from it.

## Biography

Jon Braley was born in Leek, Staffordshire
in 1976. He attended the University of
Derby 1996-99 and Winchester School
of Art 1999-2000 (including 10-month
placement in Barcelona). Group
exhibitions include *Sterling Stuff*
Tregoning Fine Art Ashbourne 2003,
*Derby Open* (2nd place) Derby Museum
& Art Gallery 2004, shortlisted for
Blindart Prize *Sense and Sensuality*

Bankside Gallery London 2006, and at
Sesame Gallery *Regroup* 2008, *Five
Years* 2008, *Wunderkammer* 2009. Also
exhibited 2009 at SCOPE Basel
Switzerland and Art Daegu South Korea.
Solo shows at Sesame Gallery London are
*The Sublime* 2006, *New Paintings* 2007,
*Myth & Nature* 2010.

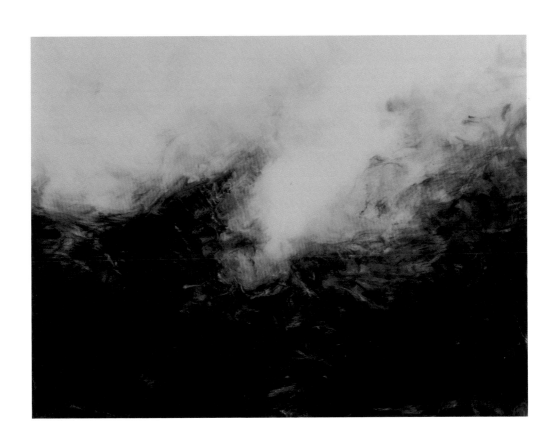

Jon Braley

# G L Brierley

## Jilly Jiggy

2009
Oil on wood
29 x 24.5 cm

This work is one of a series that examines the fetishistic nature of painting and the way it mirrors a private world.

There is a seduction/repulsion dynamic discussed in the writings of the theorist Julia Kristeva. She argues that for a child to separate from the mother, he/she has to see her as abject, which in turn renders the maternal body a site of both repulsion and attraction. This primal repression, she argues, can be displaced onto another object, a fetish. With the work, paint is poured, dripped and allowed to scab and wrinkle in layers. Amidst this unruliness, glazes are used to detail, groom and lovingly cherish the resulting object/subject in its state of becoming. The result is a 'paint personality' constructed from inherent alchemical accidents.

With this series there are echoes of the ethnographic artifact. I was thinking also of the newly discovered natural worlds depicted in 17th-century Dutch still life paintings, where ultimately the tulip became a commodity fetish. In my painting there lurks the ghost of the Victorian male collector, perhaps bringing to mind continuing contemporary themes of public/private display and the fetishistic gaze of ownership.

## Biography

G L Brierley was born in Glossop, Derbyshire in 1962. She studied at Goldsmiths College London 2005-07. Group shows include *East End Academy* Whitechapel Gallery London 2004, *The Whitechapel Auction - Defining The Contemporary* Whitechapel Gallery 2006, *Foreign Body(ies)* Whitebox New York 2007, *The Teardrop Explodes* Stadtgalerie Schwaz Austria 2007, *Artfutures* Bloomberg Space London 2007, *Light Divided* Louise Blouin Foundation London 2008. Solo shows include *The Naughty Puppies* Firstsite Colchester 2005, *New Paintings* Natalia Goldin Gallery Stockholm 2008, solo presentation in *Volta NY* (with Madder 139 London) New York 2010 and forthcoming *Matersatz* Madder 139 2010. Exhibited in *John Moores 23* 2004.

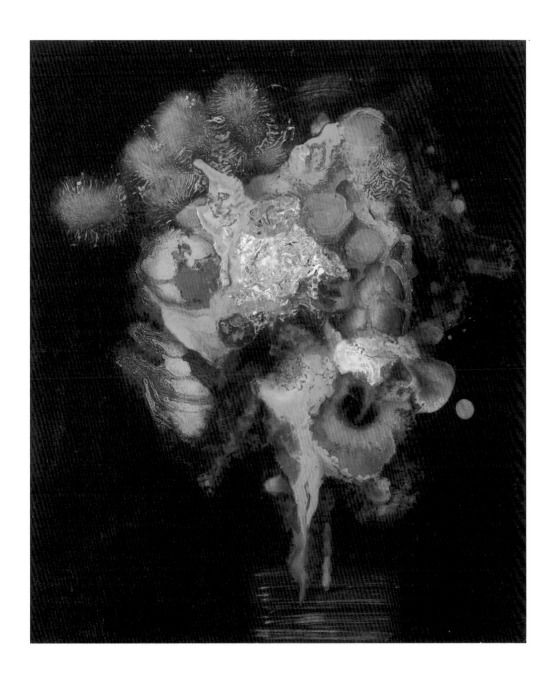

G L Brierley

# Deborah Burnstone

## Freeway

2009
Oil and acrylic on canvas
92 x 121.5 cm

*Freeway* is part of a series of paintings that explores roads and motorways. I grew up in the suburbs of London and roads and motorways were the landscape of my childhood. I am fascinated by their generality and dreary glamour. I work from my own photographs and pictures downloaded from the internet.

I painted *Freeway* after visiting Miami. I was struck by the complexity of the road networks there and the way they have redrawn the shoreline and landscape. The toxic colours of the painting reflect the artificiality of the terrain.

While my paintings are based on real places, they are as much about marks, shapes, colour and texture as the conveying of an atmosphere.

Painting is a push-pull between control and letting go. When a painting works something emerges that is in part beyond my control; equally sometimes the whole thing can fall to pieces. While an armoury of techniques, marks and materials is useful it also brings with it the threat of dreaded familiarity. So with each painting something new has to emerge or else the paintings are copies or editions and nothing has really happened - at least nothing surprising or unexpected.

## Biography

Deborah Burnstone was born in London in 1961 and grew up in Wembley and Camden Town. She studied Fine Art in London at Camberwell College 1995-96 and Goldsmiths College 1996-99, and attended the Morley College Advanced Painting Workshop 2006-09. Her work has been included in group shows including *This is Paint - Contemporary Connections* Morley Gallery London 2008, *13 Painters: The Way We See It* Morley Gallery 2009 and *Summer Exhibition* Royal Academy of Arts London 2009.

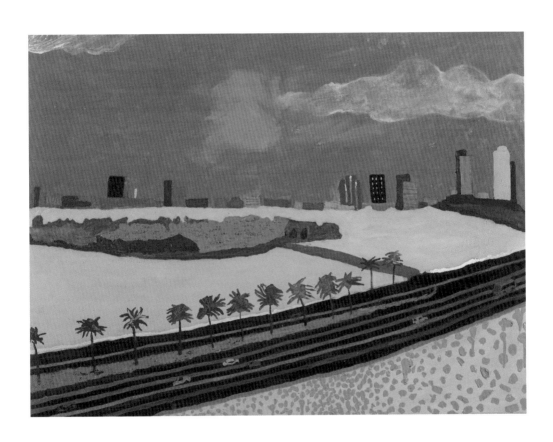

Deborah Burnstone

# Darren Coffield

## Episodical

2010
Acrylic on canvas
96 x 81 cm

For many years I have been pre-occupied with the war that rages on remorselessly across the world: The War of Images. In response I decided to search for an image, the imperial image, the image that would dominate all others, but this led only to a false notion of individuality and freedom.

Painters, like insurgents, are solitary and obscure agents, occupying unwanted spaces, preparing symbolic provocations to be unleashed on the public with a bang. I find myself surrounded by ideologies that appear contagious, perhaps inescapable, a necessary part of the human condition or a superfluous and life-threatening madness: The Society of the Spectacle.

## Biography

Darren Coffield was born in London in 1969, studying there at Goldsmiths College 1987, Camberwell School of Arts 1988-89 and the Slade School of Fine Art 1989-93. In the 1990s with Joshua Compston he formed Factual Nonsense gallery, centre of the Young British Artists scene. His London exhibitions include *A Guide For The Perplexed* Factual Nonsense 1992, *BP Portrait Award 2003* and *2010* National Portrait Gallery, *Jerwood Drawing Prize 2008* Jerwood Space and *East Wing IX* The Courtauld Institute of Art 2010. Elsewhere, exhibitions include *Plein air* Maximilian Voloshin Museum Crimea 2008 and *Turner Contemporary Open 2009* Turner Contemporary Project Space Margate.

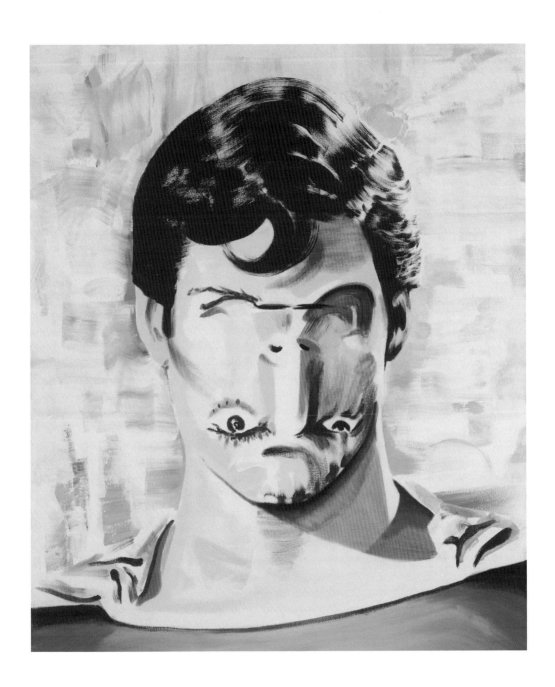

Darren Coffield

# Edward Coyle

## Multiplicity Study

2009
Oil and black gloss on canvas
119.2 x 164 cm

I am intrigued by architectural and constructional processes; the accumulation of plans, materials and structures, and the way that each stage in this process sequentially obscures the previous stage as construction advances, brick by brick, towards its intended conclusion.  A vast body of architecture exists only in the realm of the unbuilt, in the form of ideas, drawings or models. To engage in dialogue with these unrealised projections allows us to read beyond the surface of buildings, into the life of architecture.

My paintings represent my own (falsified) documentation of a building's existence, where both real and invented architectural features percolate space. The painted layers of architectural structures can refer to the past, present or future of a building as well as the unrealised futures of any abortive projections.

I use sampled architectural imagery taken from architectural plans and conceptual designs, as well as from memory and imagination. I work these sampled structures or planes up onto canvas and then expand, disassemble or destroy them with each new layer of paint. This is an automatic editing process that eventually reveals the remnants and potential developments of a building's existence.  The resulting works show an oscillation between the real and abstract, the temporary and the constant.

## Biography

Edward Coyle was born in Oxford in 1985. He studied at the University of Newcastle Upon Tyne 2004-08 and at The Prince's Drawing School London 2008-10. His work has featured in *Artisjustaword* St Anne's College Oxford 2003, at The Long Gallery Newcastle upon Tyne 2007, in *Northern Graduates 08* The Curwen and New Academy Gallery London 2008 and *New Paintings* Light Bar London 2009. He was nominated in the top ten student artists by the Editor of Saatchi Online 2008 and was long-listed for *Bloomberg New Contemporaries* 2009.

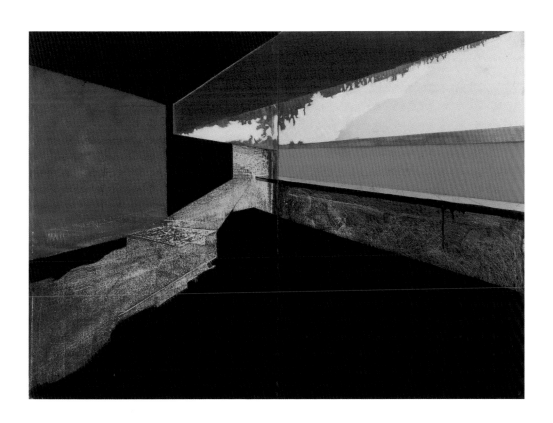

Edward Coyle

# Theo Cuff

## Untitled

2008
Oil on canvas
39.5 x 48.5 cm

A non-ironic union of tropes, a slip that occurs between the static image and abstract gesture is increasingly fascinating me. I think of my work as a deferral that remnants or residue exist beneath. These can then pass through or be withheld by the surface, so that recognition or familiarity permeates a series of paintings that becomes both intimate and ubiquitous.

When I'm building the surface of a painting it usually requires interplay between subtlety and a tactile physicality, or assertion. At the beginning there's apprehension or ambivalence, the need to get rid of the initial content.

Simplicity or the economy of a composition allows me to use the paint to affirm recognition or sometimes concealment. This will determine a finished work.

## Biography

Theo Cuff was born in Frimley, Surrey in 1984. He studied at Basingstoke College of Technology 2001-02, and the University of the West of England 2003-06 and 2006-09 (MA). Gained MAstars award AXIS website 2009. Group exhibitions include *11a* Bath Fringe 2007, *Group of 13* Basement Studio Bristol 2007, *The Wrong Place* The Old Pro Cathedral Bristol 2008, *Paint.Paint* Room 212 Bristol 2008, *Et in Arcadia Ego* The Crypt St Paul's Church Bristol 2009, *Le Salon* The New Gallery Bower Ashton Bristol, *The Show 2009: UWE Fine Art Graduates exhibitions* Spike Island Bristol 2009 and Spike Island Open Studios 2010.

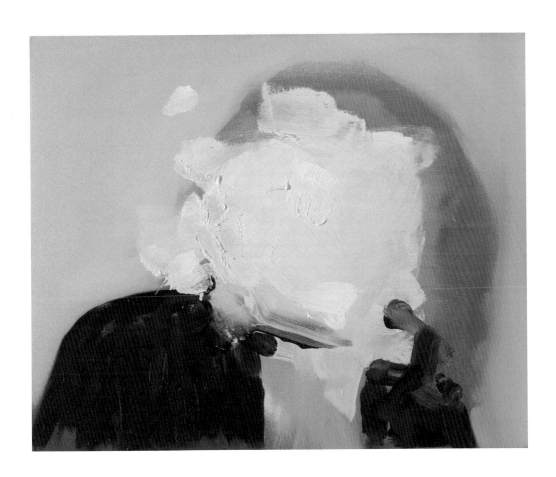

Theo Cuff

# Stuart Cumberland

## YLLW240

2009
Oil and alkyd on linen
240 x 190.3 cm

Every painting is an index of the place it was made, be it the Royal Palace for Velasquez, the solitary studio (costume and mirror) for Rembrandt, the lonely bedroom for Van Gogh or the crowded 'Factory' for Warhol. My paintings are emblems of a place where, alone and in a detached manner, I am able to commence painting by dropping my trousers and pants to my ankles and howling the names of my forebears.

Wielding a wide brush or roller loaded with dripping paint I do not consider myself to be so different to the suburban so-called sexual deviants who install a wet room for sex and pissing in the second bedroom of the house. These, my paintings, reflect a studio (a site like a wet room but less domestic and more market orientated) where the commonly repressed desires to slosh about and make a mess are processed and mediated.

## Biography

Stuart Cumberland was born in Hampshire in 1970. He studied at Bath School of Art 1989-92 and The Royal College of Art London 1997-99 (awarded the RCA Saatchi Fellowship 1999-2000). He is a lecturer and researcher at Westminster University. Solo shows are *Congratulations* The Approach London 2007, *Fort/Da* The Approach 2009, *Stuart Cumberland* Maruani & Noirhomme Gallery Knokke Belgium 2009, *Stuart Cumberland: Comma 10* Bloomberg Space London 2009 and *Gone/There* Nicholas Robinson Gallery New York 2010. Group shows include *The Way We Work Now* Camden Arts Centre London 2005 and *What Kind of Painting?* Sprüth Magers Projekte Munich 2008.

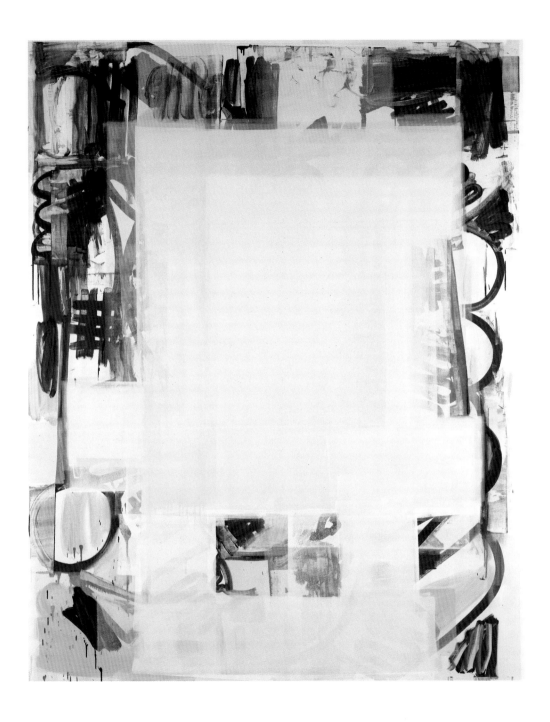

Stuart Cumberland

# Ian Davenport

## Puddle Painting: Dioxazine

2009
Acrylic paint on stainless steel mounted on aluminium panel
250 x 250 cm

I often use unconventional methods and processes in my work. In my most recent paintings, I use heavy duty syringes to pour lines of acrylic paint down aluminium or stainless steel panels. Initially precise and controlled, each line of pure colour falls down the surface until reaching the bottom where the sheet has been bent, encouraging the paint to merge and overlap, pooling and 'puddling' together. There is a delicate balance between controlling the flow of paint and allowing it to run free.

Musical influences are important to me; the repetition of multiple vertical lines of various colours creates an underlying rhythm that pulses through each work. Like a piece of music, the *Puddle Paintings* are composed of quiet, soft sections that hum in the background contrasted with intense, crescendos of brilliant colour.

The composition of repeated lines allows me the freedom to explore colour, to see how one colour sits next to another and creates different effects. They are guided by an intuitive response to colour and its sensory power.

## Biography

Born in Kent in 1966, Ian Davenport attended Goldsmiths College London 1985-88. Group exhibitions include *Freeze* London 1988, *Turner Prize* Tate Britain London 1991, *Days Like These* Tate Britain 2003, *Other Times: Contemporary British Art* City Gallery Prague 2004, *Painting as Process: Re-evaluating Painting* Earl Lu Gallery Singapore 2004, *Between the Lines* Gallery Hakgojae Seoul Korea 2007/8, *British Council Collection* Minsheng Art Museum Shanghai 2010, *Pictures on Pictures* Museum Moderner Kunst Stiftung Ludwig Vienna 2010. Solo shows include Ingleby Gallery Edinburgh 2003, Ikon Gallery Birmingham 2004, Alan Cristea Gallery London 2006, Gallery Hakgojae 2008, Waddington Galleries London 2009. His fourth appearance in the *John Moores*.

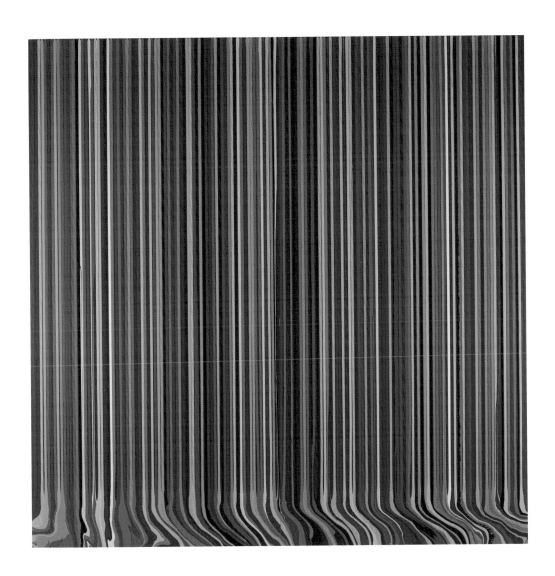

Ian Davenport

# Tim Ellis

## United in Different Guises XXXXIII

2009
Acrylic and varnish on cotton and bulldog clips
202.2 x 135.5 cm

This painting is part of an ongoing series that shares the same title, *United in Different Guises*, and which are numbered accordingly. The title refers to a proposed shared function. This function sits somewhere between a communicative role and the symbolic. The source imagery used is a mixture of signage and design which is reconstructed to form gendered symbols. The paintings' scale and material quality mimic the appearance of flags and banners. By folding, scuffing and gradually ageing the paintings, a suggested utility appears. What is left is an object that questions notions of symbolism and authenticity, allowing the work to function beyond the realms of painting.

## Biography

Tim Ellis was born in Chester in 1981. He studied at Liverpool John Moores University 2000-03 and the Royal Academy Schools London 2006-09. He lives and works in London. Group shows include *The Last Gang in Town* Arena Gallery Liverpool 2006, *Premiums* Royal Academy of Arts London 2008, *Falling from an Apple Tree by Mistake* Wilde Gallery Berlin 2008, *New Sensations* A Foundation London 2009, *TAG From 3 to 36: New London Painting* Brown Collective London 2010 and *Newspeak: British Art Now* Saatchi Gallery London 2010. His solo exhibition *A Foundation for Exchange* was at Primopiano Lugano Switzerland 2010.

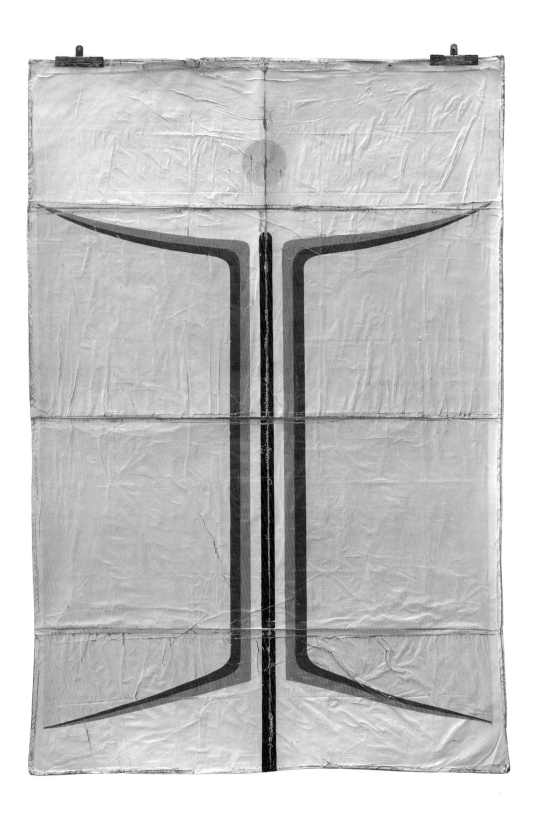

Tim Ellis

# Geraint Evans

## An Alpine Biodome

2008
Oil on canvas
200 x 179.5 cm

My recent work is concerned with the perception of landscape as a construction of culture and memory. Tourism encourages the pursuit of the 'authentic' experience and often promises an encounter with the 'natural' landscape through a packaged tour or within the boundaries of a national park, which inevitably encourages the commodification of nature.

In *An Alpine Biodome* a tourist resort has been constructed at the base of an epic mountain range. Two maintenance workers have arrived by buggy to assess their work schedule for the day whilst above them, the arching steel and glass roof of a geodesic dome maintains the perfect micro climate. Without the inconveniences of threatening fauna or an unpredictable climate this experience of the natural world might be regarded as perhaps better than the real thing. Umberto Eco articulates this argument in his essay 'Travels in Hyperreality' (1975) particularly in relation to Disneyland which, he says, 'not only produces illusion, but...stimulates the desire for it.' However, it is hard not to recall Delos, the amusement park at the centre of Michael Crichton's film 'Westworld' (1973) which, as the technology fails, descends into extreme and tragic chaos despite the resort's cheerful claim: *Welcome to Westworld, where nothing can go wrong.*

## Biography

Geraint Evans was born in Swansea in 1968. He studied at Manchester Polytechnic 1987-90 and the Royal Academy Schools London 1990-93. Solo exhibitions include those at Chapter Cardiff 2001, Wilkinson Gallery London 2000 and 2004, CASA Salamanca Spain 2003. Group shows include *Dirty Pictures* The Approach London 2003, *Other Times* City Gallery Prague 2004, *Crimes of Omission* ICA University of Pennsylvania USA 2007, *Precious Things* Highlanes Gallery Drogheda Ireland 2008, and in 2010 at Shanghai Gallery of Art China 2010 and Seongnam Art Centre Korea 2010. Exhibited four times in the *John Moores* in 1995, 2004, 2006 and 2008 (prizewinner).

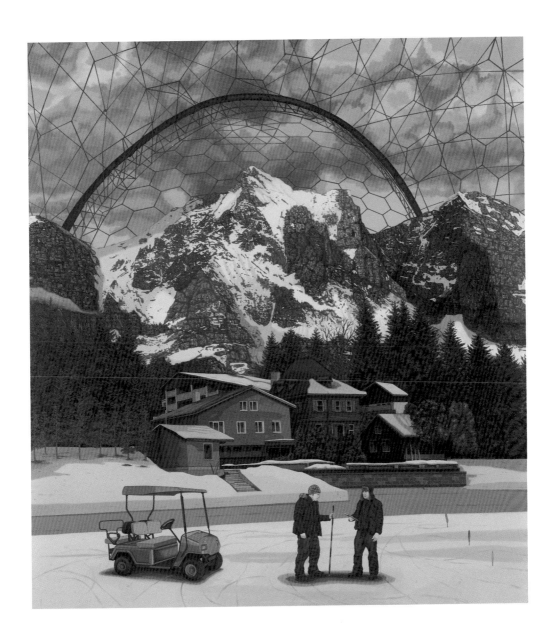

Geraint Evans

# Adam Fearon

## Untitled

2009
Sheet of pure acrylic paint over wooden stretcher
57 x 40.5 cm

In my work, which encompasses many different media including photography, installation and performance, I have always been fascinated by the idea of the surface; its elusiveness, its intangibility and its dominating role in our society.

With this piece I wanted to separate the paint from its canvas support: layers of acrylic paint were built up on glass, peeled off and then stretched and folded over a traditional wooden stretcher so that it is the surface itself which is used to make an image.

## Biography

Born in Dublin in 1984, Adam Fearon attended the National College of Art & Design there 2003-07 (Student of the Year 2007). Solo projects are *The Red Soil* Bharat Nivas Gallery Pondicherry India 2005, *I am a Photograph* Monster Truck Gallery Dublin 2006. Group shows include *The Book of Ideas* Art Scene Warehouse Shanghai 2005, *The BiG Store* Temple Bar Gallery & Studios Dublin 2007, *Won't Get Fooled Again* Café Gallery Projects London 2008, *Cat House Camp* Arts Admin London 2008, *Depot Untapped* artsdepot London 2009, and *Certain things are hidden in order to be shown* (2 person) Occupy Space Limerick 2010.

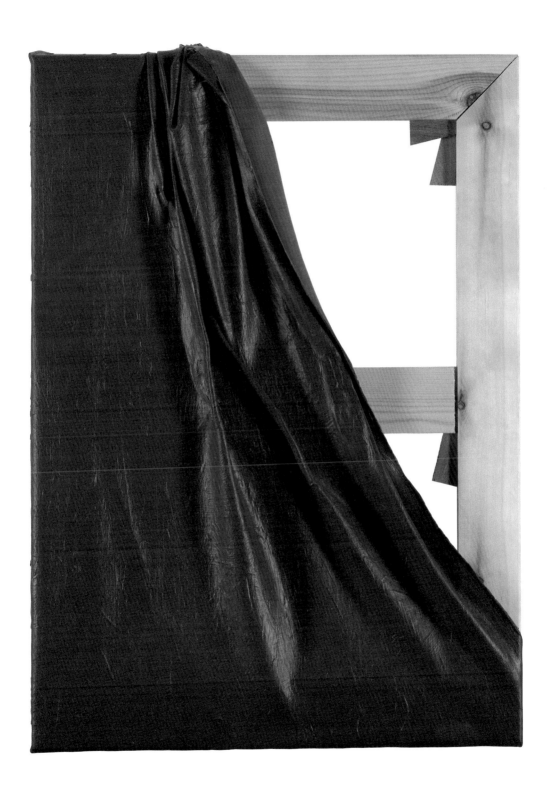

Adam Fearon

# Damien Flood

## Drip

2009
Oil on cotton
30 x 40 cm

My work situates itself between fact and fiction. The paintings I create are modern landscapes that reference the history of painting with an underlying otherworldly element. They can be seen as visual contradictions and incomplete. We are not sure what time period we are in, what place we are facing or even what planet we are on.

The scenes often don't add up. This can be because the world painted is on an immeasurable, microscopic scale or they are carefully incomplete. They appear paradoxical in nature.

I employ the tactic of incompleteness to leave the work open to the viewer and ask more questions than I give answers.

I am interested in the language of paint and how it can be employed to suggest many different notions and can be used in such a way as to transport the viewer to another time and place.

With the piece *Drip* the name suggests the action of paint dripping and becoming something else. Here it has multiplied and become what looks like a rainbow but seems to be casting a shadow, suggesting it is solid. This oddity has been taken out of the landscape and been given centre stage to be scrutinized and wondered over.

## Biography

Damien Flood was born in Dublin in 1979. He studied at Dun Laoghaire Institute of Art, Design and Technology Co. Dublin 1999-2003 and the National College of Art & Design Dublin 2006-08 (MFA). He gained the National College of Ireland Purchase Award 2008. Group shows include *Saatchi Emerging Artists Booth* SCOPE Art Fair London Oct 2008, *Mark* Oonagh Young Gallery Dublin 2008, *Anopseudonymous* 500 Dollars London 2009 and *Dawning of an Aspect* Green on Red Gallery Dublin 2009. Solo shows include *Counter Earth* Green on Red Gallery 2010. He exhibited in *John Moores 25* 2008.

Damien Flood

# David Fulford

## Near the Site

2010
Oil on boards
238 x 172.5 cm

One aspect of my painting over the past three years has involved an exploration of the portrait. In recent work I have been drawn to elements of biography and the images that surround an individual. By interpreting and reconstructing imagery from the past, I create oblique narratives that concern a desire for a sense of connectivity.

Utilising archive film footage made by my uncle before he passed away in 2006, *Near the Site* evokes a personal and nostalgic climate. Movement and sequences can be read, interrupted by dislocated still images that flash up recollections or associations, blurring definitions of time. A scene that was once visited - a building site, a playground, a garden pond - can be repeated and re-imagined from an alternate perspective. I like to play on the confusion between personal experience and collective memory as the streaming of thoughts and the act of painting muddle the distinction between documentary and fiction.

## Biography

David Fulford was born in Exeter in 1985. He studied in London at Camberwell College of Arts 2005-07 and the Royal College of Art 2007-09 (awarded The Parallel Prize at the *Summer Show*). Group exhibitions include *BP Portrait Award 2006* National Portrait Gallery London (leading to *Portraits of Nairobi* project 2006), *Free Range* G3 Gallery The Old Truman Brewery London 2007, *Drawn, Hung and Quartered* Royal College of Art 2008, *Man Group Drawing Prize* Royal College of Art 2008, *Visions of Morocco - Paramnesia Exotic* Hockney Gallery Royal College of Art 2009 and *RCA Show II* Royal College of Art 2009.

David Fulford

# Mikey Georgeson

## Untitled (Dopamine - Molecule of Intuition)

2009
Oil on canvas
60 x 60 cm

Painting the act of blowing a bubble feels like an interstice between a Newtonian view of life and a more quantum sense of spirituality. My *Tragicosmic* paintings are a distillation of a desire to capture what I consider to be episodic globules in the glistening, sticky fluid called paint. They are all from vignettes in my life when events are inexplicably book-ended. I imagine them as images forming in a primordial quantum soup. I am buoyed by feeling part of a slow-motion explosion that fleetingly forms into coherent constellations, and painting is simultaneously the expression and manifestation of this.

My art stems from a desire to live in the here and now coupled with the nausea of seeing those yellow police signs on the street that say, 'Life is cruel'. Painting enables me to simultaneously examine life as it is and as 'other' than as it is. I am suspicious of painterly flourishes yet drawn to the transcendental effects of gloopy pigment. "To see that which is under your nose requires a constant struggle", said George Orwell and, indeed, the bubble in the painting is a fleeting moment hovering between struggle and whim right under my nose.

## Biography

Born in 1967 in Bexhill-on-Sea, Mikey Georgeson attended Worthing College of Art 1985-86, Chelsea School of Art London 1986-1989 and Brighton University 1989-91. Group exhibitions include *Wapobaloobop* Transition Gallery London 2008, *Legends of Circumstance* Whitecross Gallery London 2009, Bargate Gallery Southampton 2010 & Liverpool Biennial 2010. London solo shows are *My Magic Life* Sartorial Art 2008, *Father, Son & Holy Smoke* Bear Gallery 2009, *Tragicosmic* Sartorial Art 2010. London performance art includes *Mr Solo* Whitechapel Gallery 2009, and in 2010 *Artist As Scapegoat* Norn Projects, *Return of the Repressed* Portman Gallery, *This Happy Band* South London Gallery. Sings in 'David Devant & His Spirit Wife'.

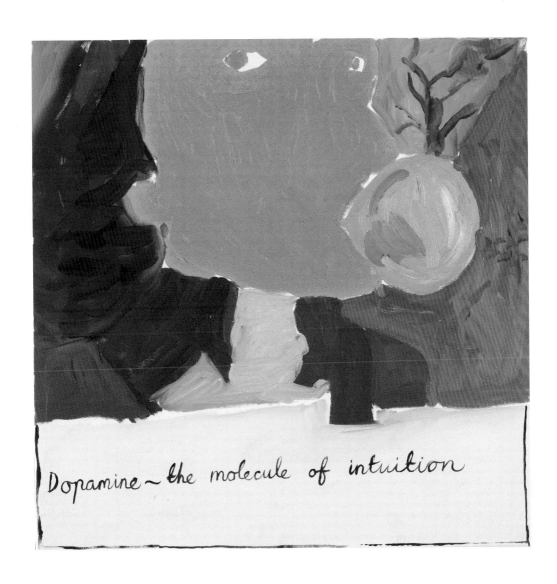

Dopamine ~ the molecule of intuition

Mikey Georgeson

# Chris Hamer

## Crook

2010
Acrylic on canvas
25.5 x 20.5 cm

The calm facture of my paintings contrasts with an interplay of plane and depth, which leads to a tension between the abstract quality of the images and the subjects suggested.

I abstain from planning by instigating a non-linear state in which colours from one image are transposed onto another. Continued application and removal leads to a fluid relationship between layers of paint, which are then fixed in the final work.

## Biography

Chris Hamer was born in Bolton in 1970 and studied at Leeds Polytechnic 1989-92. He was the Co-Chair of Object Studios Limited, Manchester 1995-1997 and lectures in Contextual Studies at Mid-Chester College (for Chester University). His exhibitions include *Leeds Open Exhibition* Leeds City Art Gallery 1992, *Art of the Sacred* Egton Priory North Yorkshire 1993, *Manchester Academy of Fine Art* Manchester City Art Gallery 1993, *Stockport Open* Stockport Art Gallery 1994, *Object One* 29 John Dalton Street Manchester 1994, *Compartment* Rogue Studios Manchester 2005 and *Mini-Series* 85 Rockdove Avenue Manchester 2006.

Chris Hamer

# Andy Harper

## Frau Troffea

2009
Oil on canvas
45 x 40 cm

Bishops, popes and Papal Councils had for centuries tried to suppress such frivolity. Geiler thundered that it was 'the ruin of the common people'. Dance might even, people said, expose poor sinners to the enchantments of the Devil. It certainly, they insisted, led to untold bastard children. But when the opportunity arose, the common people got to their feet to dance because it felt so good. Rapid rhythmic motion was invigorating, liable to give them the transporting rush and long moments of welcomed amnesia. It acted like an opiate on the mind, soothing and enervating. All of a sudden they were less frighteningly alone.

(*A Time To Dance, A Time To Die* by John Waller, 2008)

## Biography

Born in Hertfordshire in 1971, Andy Harper attended Brighton Polytechnic 1990-93, the Royal College of Art London 1993-95 and Middlesex University 1997-99. With Abigail Reynolds he runs Assembly, a live/work space in St. Just, Cornwall. He teaches at Goldsmiths College, London. Group shows include *Darkness Visible* Galway Arts Centre Ireland 2007, *Curious Nature* 2007 and *Wastelands* 2008 Newlyn Art Gallery and *East End Academy* Whitechapel Gallery London 2009. Solo exhibitions include *New Paintings* One in the Other London 2008, *Recent Paintings and Works on Paper* Danese Gallery New York 2009 and *An Orrery for Other Worlds* Aspex Portsmouth 2010. In *John Moores 24*, 2006.

Andy Harper

# Richard Harrison

## Mountain Peaks

2008
Oil and acrylic on linen
190 x 225 cm

When I am asked what sort of artist I am, I describe myself as a 'Romantic Expressionist', because my painting is emotionally charged, the paint handling is expressionistic, and the wellspring from which the work is drawn is fundamentally aligned to the Romantic vision. There are the imaginary landscapes, inspired by wilderness, mountains and desert and the organic forms of rocks and trees, and *Mountain Peaks* is one of these. And then there are the figurative works, often revolving around biblical and mythological stories or scenes from poetical works. My landscapes are swirling storms and desperate rock faces, and my figures are embattled and flayed harbingers of pestilence and death. Brian Sewell, in his book *'Nothing Wasted: The Paintings of Richard Harrison'*, published in February 2010, concludes with this: 'Soon to be fifty-five, Harrison's intellectual house is now in as respectable order as his studio. We should look at him not as a painter comfortably settled in middle age, but as a young painter with at least as much ahead of him as in his past, a young painter of un-diminishing turbulent enquiry, but with all the advantages of practice, maturity, education and broad experience.'

## Biography

Richard Harrison was born in Liverpool in 1954. He attended Cambridge University 1973-76 (History), The London College of Furniture 1981-83, and Chelsea School of Art London 1984-88 (painting). He lives and works in London. He featured in *Young Masters*, selected by Brian Sewell for the *Mail on Sunday* The Solomon Gallery London 1987. London solo exhibitions include those at The Berkeley Square Gallery 1989, *Paintings* Jill George Gallery 1993, shows at the Albemarle Gallery in 2002, 2003, 2006, 2008 and most recently there, *Nothing Wasted* 2010. His triptych *Crucifixion: At The End... A Beginning* hangs in Liverpool's Anglican Cathedral.

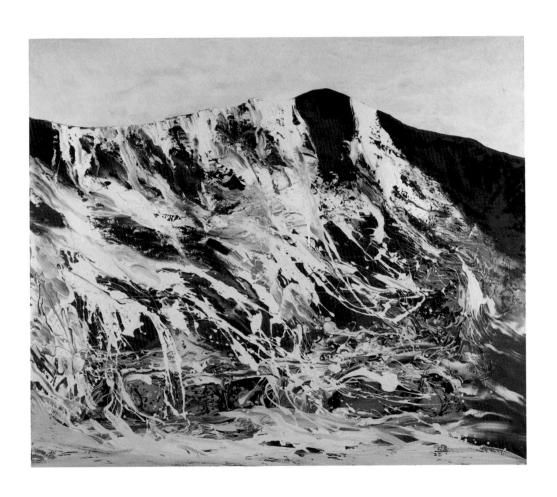

Richard Harrison

# Sigrid Holmwood

## Butchering a Pig

2010
Handmade paints including fluorescent egg/oil tempera, cobalt blue, lead white, lead antimonite, burnt sienna, raw sienna, vermillion, ultramarine ashes, verdigris and madder in oil on linen
90.3 x 115 cm

This painting is not a definitive product but part of an ongoing performance. I make all of my paints by hand, researching historical recipes and techniques gleaned from old treatises and conservation reports. I find my subject matter in historical re-enactment groups who have a similar passion for materials and craft, acted out in their hand-stitched, vegetable-dyed clothes, displaying skills vital to a pre-industrial age - such as the traditional butchery of a Tamworth pig. Indeed, I have joined these groups, re-enacting a 16th-century painter showing the public how paints are made, inhabiting open air museums, sleeping on straw mattresses and eating food cooked on open fires.

The Performance of Painting continues now as the viewer takes their role in the act, just as in the contemporary museum reconstruction the public is asked to suspend their belief in order to partake in the spectacle. If the viewer accepts the premises of this psychedelic *theatrum mundi*, Bruegel can meet Van Gogh, fluorescent pigment can be bound in egg, and the Slow Food movement with its rare-breed meat and home-grown vegetables is translated into a Slow Paint movement of hand-ground pigments and sun-bleached oils.

## Biography

Sigrid Holmwood, half-British, half-Swedish, was born in 1978. She attended the Ruskin School of Drawing & Fine Art Oxford 1997-2000, the Royal College of Art London 2000-02 and the British School at Rome 2003-04. She featured in *Responding to Rome* Estorick Collection London 2006, a collaborative artists' book in *Cunning Chapters* The British Library 2007, *The Artist's Studio*

Compton Verney Warwickshire 2009 (artist in residence) and *Newspeak: British Art Now* State Hermitage Museum St Petersburg 2009 and Saatchi Gallery London 2010. Solo shows include *PastTimes and Recreation* Transition Gallery London 2006 and *1857: Paintings* Annely Juda Fine Art London 2008.

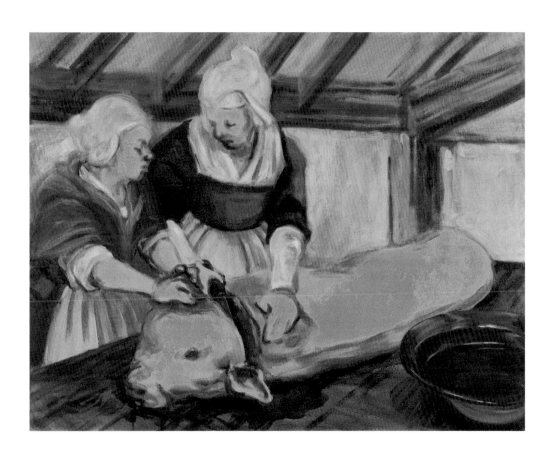

Sigrid Holmwood

# Phil Illingworth

## 3D painting No.1 (experiments with colour reflection)

2010
Acrylics, blue household emulsion, gesso and MDF
30.5 x 50.5 cm

I have been returning to and re-examining the basics and this has become a rich and absorbing source of inspiration for me. This piece is the first of a series of explorations into the interaction of light, plane, surface and colour, and the varying and sometimes surprising ways in which colour reflects to alter the surfaces around it. I also wanted the unpredictability of changing light conditions to play a part. I sought to experiment with observations pared back to a few fundamental premises; in this instance using non-representational shapes, simple colour, and hues which seem almost 'mute'. On the one hand this is a magician's conceit - making colours appear out of nowhere; on the other it is the opposite, laying bare some of the mechanics of the magic of light.

I see this work very much as a progression. To some extent it represents a return to basic principles, yet it does so in a way which, at a personal level, both re-informs and revitalises. As a continuation of my practice, it coincides with a long-held interest in testing what I see as a kind of emotional hybrid between two and three dimensions.

## Biography

Phil Illingworth was born in 1955 in Yorkshire. He studied at Portsmouth College of Art 1975-78 and spent much of his earlier career as a graphic designer. His group shows include *101* CryBaby Gallery Asbury Park NJ USA 2008, *Mink Schmink* WW Gallery London 2009, *Affluenza* 187-211 St John Street (temporary space) London 2009, *PG: Parental Guidance* WW Gallery 2009,

*Travelling Light* WW Gallery and Pharos Gallery London 2009 then *53rd Venice Biennale* 2009, *Come Together* CoExist + Metal Southend 2009, *Time* WW Gallery 2010. The solo show *Little Gods* was at GASP Portsmouth in 2009.

Phil Illingworth

# Lee Johnson

## The Kerchief or Dr. Olfato's Welcome

2009
Oil on linen
65 x 45.2 cm

There are many levels of reality that are picked apart through diverse disciplines such as philosophy, art and the novel. Within painting, and specifically portraiture, there are painted realities and painted fictions; fictitious paintings and fictional realities.

Since moving to a new studio and ditching all my previous work (except a small quasi-religious painting of a bearded man with a silver platter of fish balanced on his head) I bought my first easel and *sat down* to paint for the first time. When I wasn't painting I was writing and characters developed in my paintings through the writing of short stories, which I may or may not get around to publishing.

Painting and the portrait have rich histories that cannot be refuted yet can always be undermined, both of which may or may not be good things. I attempt to hover between the two.

## Biography

Lee Johnson was born in Wiltshire in 1975. He studied at Leeds Metropolitan University 1994-97 and Central Saint Martins College of Art and Design London 2000-01. Group shows include *Lexmark European Art Prize* Air Gallery London 2002, *Narcissism: Self-Love to Death* GOZOcontemporary Malta 2003, *Scenes in Perspective* Artower Agora Athens 2003 and *High Risk Painting* Northern Gallery for Contemporary Art Sunderland 2006. A recent solo show was at *The Free Art Fair 3* Barbican London 2009. A short story 'The Same' in a collection called *Thirteen Stories* was launched at Whitechapel Project Space London 2005 (Miller & McAfee Press).

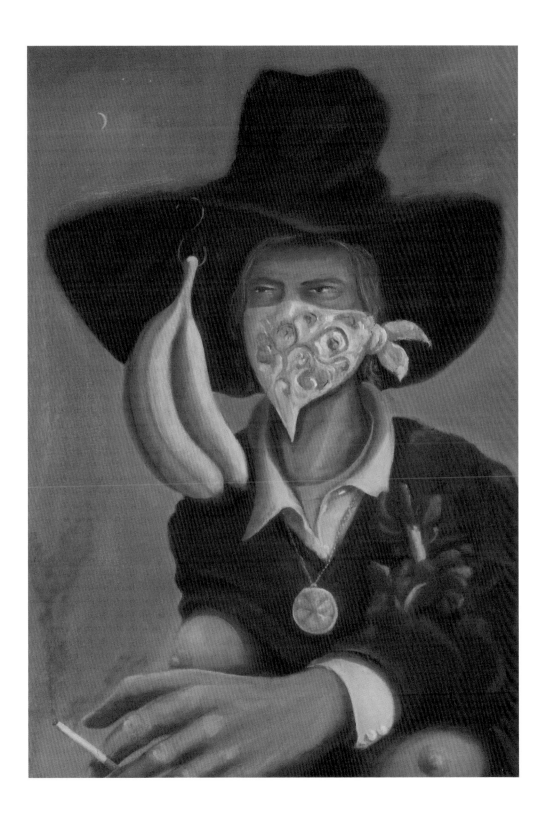

Lee Johnson

# Neal Jones

## Orange Paving

2009
Oil on board
74.5 x 61 cm

I am looking for an image of self-contained wildness. I find painting deliciously mysterious and happily limited.

I am inspired and deterred by the insane beauty and detail of my allotment garden, where I paint daily. From the bacteria in the soil to invisible foxes, rats and owls that patrol at night, it is impossible to show it all. Here too is culture-war-news. The complex biodiversity in time and motion can only be generalised. *Orange Paving* is a diagram of my failure to illustrate it. Now I prefer to knock together an absurd community of biological personalities, awkwardly interrelated.

The strong formal elements are defiant life-swipes against inaction, routes out of mannerism, politeness and pop. The spirit and gesture of the London School and early modernist paintings are referenced as are universal cell-structures and wobbly, wooden allotment structures. The ventilated spaces are fuelled with a desperate smiley face; they act as both animation mark and fatalist signature. I'm hanging on to representation but not necessarily human.

## Biography

Neal Jones was born in Liverpool in 1969. He studied at Canterbury College of Art & Design 1989-92 and the Prince's Drawing School London 2002-03. Since 2008 he has been an assistant to artist Tess Jaray. Solo exhibitions are *Look out* Tess Jaray's shed London 2009 and *New Paintings and Hand Made Things* L-13 London 2010. Other exhibitions include *Small is Beautiful* Flowers East London 2008, *Winter Salon* Temple Bar Gallery Dublin 2008, *Summer Exhibition* Royal Academy of Arts London 2009 and *I am the good artist* (2 person) L-13 London. He was a prizewinner in *John Moores 25* 2008.

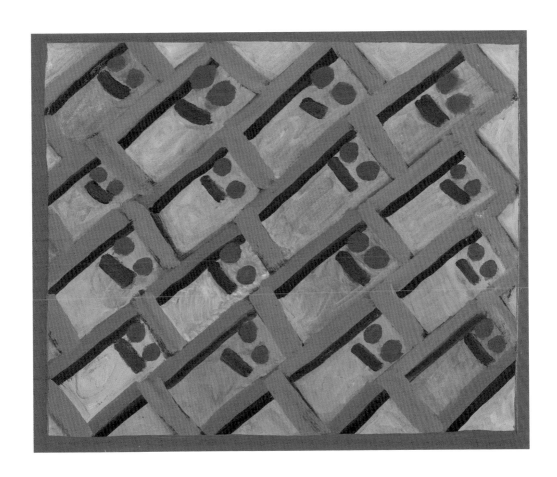

Neal Jones

# Joseph Long

## Hortus Botanicus

2009
Oil on linen
27 x 18.3 cm

*Hortus Botanicus* is a botanical painting covered in bubble wrap.

## Biography

Joseph Long was born in London in 1985. He attended University of the Arts London, Wimbledon School of Art 2005-08, Gerrit Rietveld Academy Amsterdam (Fine Art Scholarship) 2006-07 and The Royal College of Art London 2008-10. He was awarded a Citè Internationale des Arts Studio Residency Paris 2009. Exhibitions include *PA/////KT* at PA/////KT Amsterdam 2007, *Bloomberg New Contemporaries* A Foundation Liverpool (Liverpool Biennial) and Rochelle School London 2008, *The dot at the top of an i* (2 person) Holy Trinity Church London 2010, *I.P. Rights Attached to Plants* The Public School Los Angeles and *FAST FERTIG* The Oubliette London 2010.

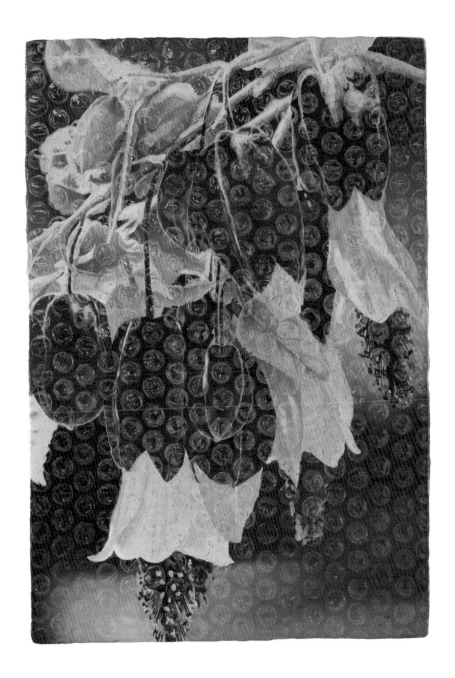

Joseph Long

# Elizabeth McDonald

## Bee Keepers I

2010
Oil on paper
29 x 41 cm

My paintings have an anecdotal quality but not a singular narrative. They are often based in reality but become skewed towards the uncanny through the use of colour, composition and invented detail. There is a balance between dissonance and beauty; one is left with only precarious assumptions of story or subject yet one is not driven away by the uneasiness within the painting.

## Biography

Elizabeth McDonald was born in Plano, Texas in 1985. She studied at Southern Methodist University Dallas 2003-05 and the University of North Texas 2005-08. She is currently at Glasgow School of Art 2009-2011 (MFA). She was shortlisted for the *London International Creative Competition* 2009 and was a finalist for *The Hunting Art Prize* Houston Texas 2010. She exhibited at *Expo* 500x Gallery Dallas Texas 2010 and *Chalet Invitational* The Chalet Glasgow 2010. Most recently she has featured in the *BP Portrait Award 2010* National Portrait Gallery London (winner of BP Young Artist Award 2010).

Elizabeth McDonald

# Michael Miller

## Suspended Animation

2010
Black 'International' exterior gloss on canvas
153.5 x 112 cm

*Suspended Animation* is a painting that reflects the event it sees. Mirror gloss surfaces are disturbed by the interaction between areas of uncured paint flowing beneath the surface tension. The paint's internal movement literally characterises the drip, the belly - the stretch marks seen on the surface skin. Each painting's form is governed by the dynamics of the making process and continues to change its face until it finds its own resting point.

The reflections hold the observer as subject, the space as containment and, voyeuristically, they hold the performance of the moment, confined within the surface as it plays out. I can only set up and direct the process, wait for the surface to dry and then enjoy the peace as the paint begins to flow and the painting forms itself.

## Biography

Born in Bowden, Cheshire in 1965, Michael Miller lived his formative years on the edge of the Peak District, Derbyshire. He studied biochemistry in Manchester 1983-86 then fine art at University of Wales Cardiff 1994-96, and tutored there until 1997. From 1997-2009 he worked in the automotive industry innovating and developing a design and prototyping process for surface aesthetics. He returned to painting in 2009. He exhibited in *MA Degree Show* Cardiff 1996, at Art Space Bristol 1997 and has a forthcoming installation of new work at St Mary's Church Wirksworth Derbyshire as part of the Wirksworth Festival September 2010.

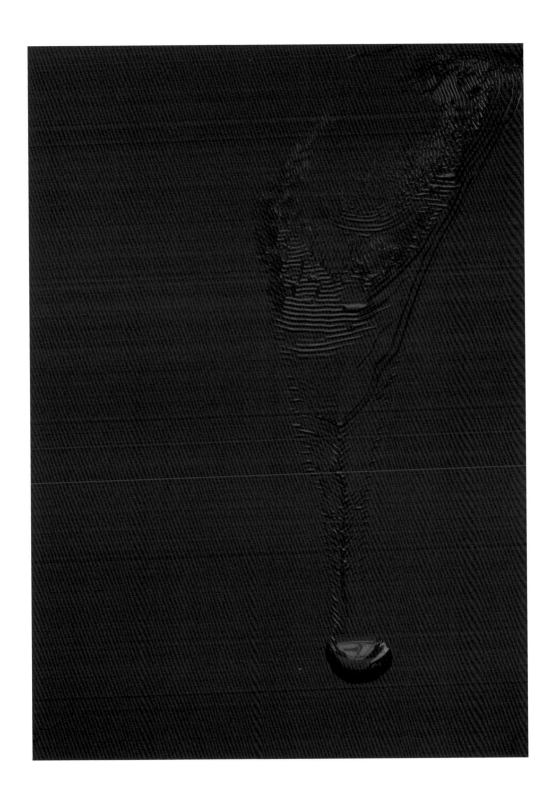

Michael Miller

# Matthew Mounsey

## Prehistoric Sex Machine

2009
Acrylic on canvas
150 x 135 cm

Doodles, folk art, cave painting and graffiti are all things I like. I want my paintings to be as free as a thumbnail sketch, to have a look of ease about them.

Recently I have been doing small drawings. I'll make them and they will inform my paintings. I don't do paintings from drawings but they play an important role. I always hope for the unexpected to happen. Flatness and form is something I like to mix in my work; two or more worlds meeting and living in the same space.

## Biography

Born in London in 1967, Matthew Mounsey attended City and Guilds of London Art School 1986-89 and the Royal Academy Schools London 1997-2000. Group shows include *Defrosted* Refrigerator Studio London 1995/6, *W&N Young Artist of the Year* Mall Galleries London 1996, various Cricket Hill Gallery New York 1998-2000, *RA Schools Show 2000* Royal Academy of Arts London, Keith Talent Gallery London (drawing show, toured USA) 2003 and *Summer Exhibition* Royal Academy of Arts 2009. London solos include *Paradoxical Serendipity* Bruton Street Gallery 1993 and at his open studio *Painting and Drawing* 2007, *Dream On* 2008, *Drawing on the Brain* 2009.

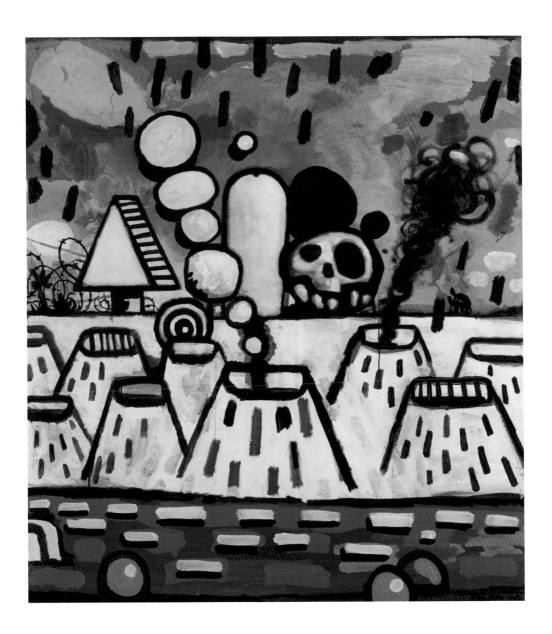

Matthew Mounsey

# Jost Münster

## To the Left

2009
Mixed media on wood
242 x 368 cm

Jost Münster's works experiment with colour and the painted surface, exploring the reaches of representation. Working from his urban surroundings, Münster strips away pictorial detail and flattens and collages surfaces with abstract, mosaic-like colour swatches and backgrounds. Using shapes and silhouettes derived from the interplay between architecture and the painterly aspects of the everyday, a new and subtle vocabulary of forms and references is forged. The works both invite a genuinely formal response, but also question their own status as either paintings or sculptures. This type of distinction establishes the backdrop to his oeuvre as the presence of a set of possibilities that remain significantly undefined.

With a distinct musicality the interplay of forms and textures resonates within a series of individual works, and equally as an installation bound by a varying use of rhythms, speeds, punctuations and chords of colour. These move seamlessly throughout. His work offers a playful and subtle figuration. By continually subtracting points of reference, it treads a fine line between being weathered and depleted, and conversely, entirely full of fresh content. The painterly marks that obscure and delete become potent and colourful scapes.

## Biography

Born in Ulm, Germany in 1968 Jost Münster studied at The Fine Art Academy Stuttgart 1990-98 and Goldsmiths College London 2002-03. Group exhibitions include *Artfutures* Bloomberg Space London 2007, *Layer Cake* Fabio Tiboni Arte Contemporanea Bologna 2007, *Thames Mudlarks* CTRL Houston Texas 2008, *Hypersurface FX* Margini Arte Contemporanea Massa Italy 2009, *Celestial Suitcase* 476 Jefferson Street NY 2009, *A Sort of Night to the Mind...* [abbreviated] Herbert Read Gallery Canterbury 2009, *Mexican Blanket* Museum 52 London 2010, *Urban Origami* PM Gallery & House London 2010. Recent solos are *Ground Control* Museum 52 2010, *Refuge* Kunstverein Friedrichshafen Germany 2009. Exhibited in *John Moores 24* 2006.

Jost Münster

# Cara Nahaul

## Somewhere Between Prayer and Agenda

2009
Oil on canvas
160 x 200 cm

My practice is principally centred on the issues of cultural memory, race and hybridity. Greatly informed by my background of mixed cultures, it explores the tension inherent between 'alien-ness' and belonging and questions how truthfully or objectively I can represent a given group of people. Coming from two diverse minorities, I have often identified with the alien that we are accustomed to seeing in films and reading about in literature. This sense of alienation has been the source of my creativity. What I seek to explore in my paintings is the construction of images within the documentary form. The paintings are based on stills taken from a documentary that aimed to 'uncover' fundamentalist preaching in British mosques. The prayer scenes shown in the film were simply that, as opposed to a method of encouraging new Islamic fundamentalists. My paintings are borne out of distrust for these images and a desire to reclaim some honesty from the documentary.

It is this often unfair discrepancy between actuality and perception which is the main objective of my practice. My intention is to try and disturb the certainty with which our determinations of reality are made.

## Biography

Born in St. Albans in 1987, Cara Nahaul studied at Goldsmiths, University of London 2006-09. Her exhibitions include *Curiosophy* Red Gate Gallery London 2008, *Circuit Wisely* Shoreditch Town Hall London 2008, *FringeMK* Project Space 1 Milton Keynes 2009, *X presents... Heart of Dixie UK* 53 High Street Romford 2009, *National Open Art Competition* (chaired by Gavin Turk)

Minerva Theatre Chichester 2009 (winner, Heart of England Regional Prize), *London Vox* Red Gate Gallery 2010 and *Silent City* The Rag Factory London 2010. She is a founder member of the collective Silent City.

Cara Nahaul

# Narbi Price

## Untitled See Saw Painting

2009
Acrylic on canvas
80 x 120 cm

On the way to the library to write this, I was sure I was going to see an empty packet of Space Raiders by the bus stop but all I found was an apple core and a green balloon, unblown. Laurie Anderson once said that novels are full of things happening but she wanted to write a novel about the spaces in-between, where nothing was happening. It takes a certain state of mind to choose a neutral object as your subject, to choose the mundane over the dramatic, the trivial exterior over the florid treasures of the inner world. On one level, there's a disavowal of the grandiose and histrionic; on another, a gentle subversion of the hierarchy of values that underpins our seeing.

In their carefully crafted blandness, Price's paintings signify the presence of a willingness to let the world speak for itself. The absence of human subjects and deliberate lack of narrative place the viewer in a uniquely familiar position - alone with the world as it is. The neutral object steers us between the poles of attraction and aversion, and confronts us with the ambiguity of the everyday - the places we inhabit while nothing's happening.

(Text by Nev Clay, originally published in part in *Summer 2009* show catalogue, August 2009)

## Biography

Narbi Price was born in 1979 in Hartlepool. He attended Cleveland College of Art and Design 1998-99, Northumbria University 1999-2002 and Newcastle University 2008-10 (MFA). Group exhibitions include *Fresh Art* Business Design Centre London 2002, *Northern Graduates* The Curwen and New Academy Gallery London 2003, *Group Show* Newcastle Arts Centre Newcastle upon Tyne 2005, *Quattro* Moot Hall Gallery Hexham 2008, *PRINT* Mushroom Works Newcastle upon Tyne 2009, *Summer 2009 MFA Show* Hatton Gallery Newcastle upon Tyne and *Laugh? I Nearly Bought One* Richard Ling Gallery Newcastle upon Tyne 2010. Narbi plays in the Newcastle-based bands Chippewa Falls and MeandthetwinS.

Narbi Price

# Steve Proudfoot

## The Party

2010
Oil on paper pasted onto board
69 x 98.7 cm

I have come to realise the following:

My paintings should show what cannot be expressed any other way.

My paintings should express human drama.

We are daily bombarded with visual imagery through advertising, photography, television and film. Therefore the photographic image is in my head whether I like it or not.
My painting tries to avoid but usually confronts this fact.

My paintings attempt to transform the everyday casual moments into significant ones.

## Biography

Steve Proudfoot was born in Liverpool in 1950. He studied at Warrington College of Art 1969-70, Manchester Polytechnic 1971-75 (fine art) then Manchester School of Art 1976-78 (MA fashion & textiles). Whilst pursuing art in a variety of media he has worked in occupations including hospital porter and Head of Foundation at Bury College. His commissions include work for schools and churches in the North West. Group shows include *Patchings Open Art Competition* Patchings Art Centre Calverton Nottingham 2007 (ProArte Award prizewinner) and 2008 (Royal Talens Award prizewinner), and *Waterside Open 2010* Waterside Arts Centre Sale (3rd prizewinner).

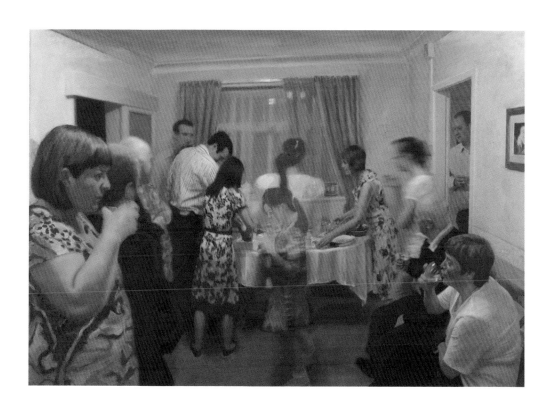

Steve Proudfoot

# Sabrina Shah

## Witness

2009
Acrylic on canvas
152.2 x 183 cm

Whatever one's calling in life, a lawyer, an actress, a teacher, a rapper, a famous sports star, a humble husband or wife or an artist, I believe commitment and self expression are very important.

As the viewer you are often the judges of our fate. Good reviews can determine an artist's career. Bad reviews can just as easily destroy. We can guide and influence as best we can through the most effective means. My paintings have always been my most powerful means of self expression.

The main inspiration for my work has been the theatre. Initially fascinated by the stage - the space for characters, lighting and emotional outpouring - I then viewed the performance from the audience's perspective; how important their role is to a performance as the ultimate arbiters of success.

Someone will rarely allow you to influence and change his or her subconscious. But unknowingly our audiences present us with an opportunity to do that.

## Biography

Sabrina Shah was born in Worcestershire in 1986. She studied painting at Brighton University 2006-09 and scenic art at the Royal Academy of Dramatic Arts London 2009. She will attend The Prince's Drawing School London from September 2010. Exhibitions include *Pigment Freud, Burt Brill & Cardens Graduate Show* University Gallery Brighton 2009 (prizewinner), *The Open West* Cheltenham Art Gallery and Museum 2010 (2nd prizewinner) and *West Midlands Open 2010* The Gas Hall Birmingham. Solo shows include *Face Painted* Lydea Café (gallery space) Brighton 2009 and *It's Show Time* Agar Galleries Henley on Thames 2009.

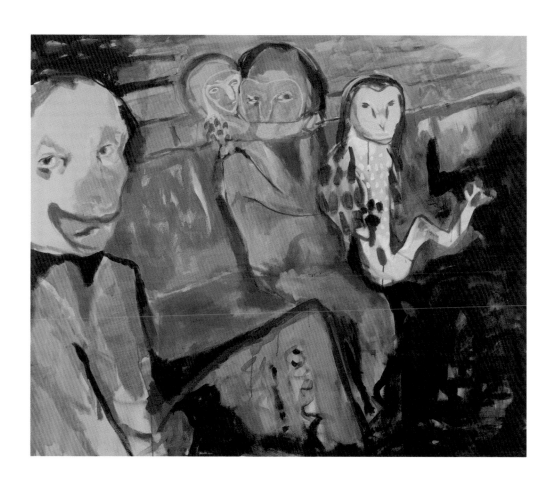

Sabrina Shah

# Annabelle Shelton

## Helter Skelter Runway

2009
Watercolour paint, watercolour pencil and graphite pencil on
aluminium
53 x 74 cm

Amongst the foliage I peer across the shore at a quasi-fairground on the beach that animates the landscape.  All sorts of things enter my mind. It is neither positive nor negative. I either want to participate or abstain. I want to frolic within the scene but it is not all there and not all safe.

*Helter Skelter Runway* is part of a series, *Helter Skelter*, where clips are taken from an English beach. The beach has become a personal, psychological landscape and many ideas are worked into the compositions. They are created like mindful assault courses of disposition and optimism.

The unfinished look of the work is deliberate, as the white negative space is like a void of nothingness but also gives us a resting space amongst the painting.  White space is often present in my work and signifies that which does not need to be said. The intention of my work is subtle and necessary in its rendering, for the quietness is what I like to explore amongst a chaos of animation.

## Biography

Born in London in 1968, Annabelle Shelton attended Staffordshire University Stoke on Trent 1989-92 and UCE Birmingham 1997-2001. Exhibitions include *The Discerning Eye* Mall Galleries London 2005 (drawing bursary finalist), *The Figure Show* Jill George Gallery London 2006, *Art Chicago 2006* (with Jill George Gallery), *Conjunction 06 'Transpositions'* Airspace Stoke on Trent, *Articulated Landscapes* Three White Walls Birmingham 2007 (solo), *Diffusion of Useful Knowledge* (her studio, curator/exhibitor) Milton Keynes 2009, *Presents* ('Market Project' collaboration) Wysing Arts Centre Cambridge 2010 and *5* Aberystwyth Arts Centre 2010. Exhibited in art fairs worldwide. Forthcoming solo show Rarity Gallery Mykonos Greece 2011.

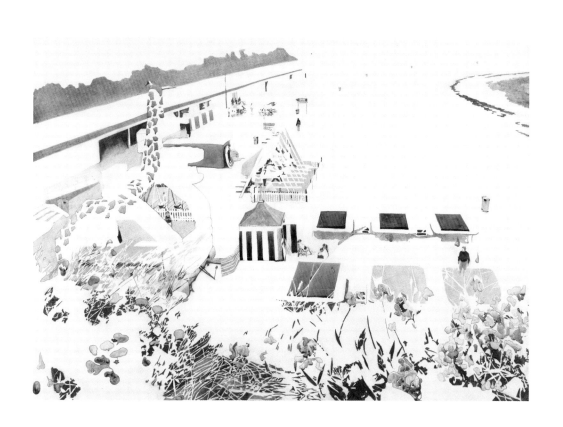

Annabelle Shelton

# George Sherlock

## Polycrylic Decades

2009
Acrylic on polythene
175 x 232 cm

My recent practice has involved exploring and extending the possibilities in the use of acrylic paint on different surfaces. Looking for a technical solution that could generate new content has led to experimentation with a whole range of domestic chemicals mixed with acrylic. In its preparation the paint is balanced from thick to thin and sometimes includes commercial polymer house paints. Images are painted on the studio floor where the polythene is turned into a shallow bath in which paint is allowed to mix and separate according to the quantity of water used. This settles into its own structure and the drying process can take weeks. The process allows for the extraction and addition of water and new paint which generates unexpected configurations. Finally the image is reversed either through printing onto a surface, or, as in *Polycrylic Decades*, is viewed through the polythene sheet.

This painting is a new departure, stopping at an earlier point in the overall process than usual. The phrase 'ironic sublime' came to mind since the materials with which I am creating images, within the traditions of modernist abstraction, have prompted a self-consciousness towards the degradable qualities and effects of the plastics and chemicals used.

## Biography

George Sherlock was born in Liverpool and studied at the College of Art there 1959-63. He won the Liverpool Artists' Prize, travelling to Spain on a Liverpool Senior City Travelling Scholarship. He was Senior Lecturer in painting at Coventry University 1983-2003. Exhibitions include *I/Am/Is/Are* Arvore Gallery Porto Portugal 1998 (solo), *Painting Open* Royal West of England Academy Bristol 2001 (1st prize), *2020; '20 Artistas' No.20 Anniversario* Centro De Arte De S.Joao Da Madeira Porto Portugal 2006, *Drawing Breath* Gallery Lugar Do Deseno Julio Resende Foundation Porto Portugal 2008, *Sunday Times Watercolour Competition-Parker Harris* Mall Galleries London 2010. Exhibited in *John Moores 7* 1969.

George Sherlock

# Michael Simpson

## Bench Painting Untitled

2010
Oil on canvas
183 x 365.5 cm

This is a *Bench Painting.* It is the last work of a series which I began in 1989.

## Biography

Born in Dorset in 1940, Michael Simpson lives and works in Wiltshire. He attended Bournemouth College of Art 1958-60 and the Royal College of Art London 1960-63. Solo exhibitions include *Six Large Paintings* Bristol Museum and Art Gallery 1973, *Paintings 1980-1983* Arnolfini Gallery Bristol 1983, *Recent Paintings* Serpentine Gallery London 1985, *Bench Paintings 1992-1995* Arnolfini Gallery and Oriel 31 Newtown 1996, *Bench Paintings, Recent Work 2005-2006* David Risley Gallery London 2007, *Bench Paintings and works on paper* Volta New York 2008, *The Bench Painting Series, A Survey, 1989-2010* URA Istanbul (supported by the British Council) forthcoming 2010. His fourth *John Moores* exhibition.

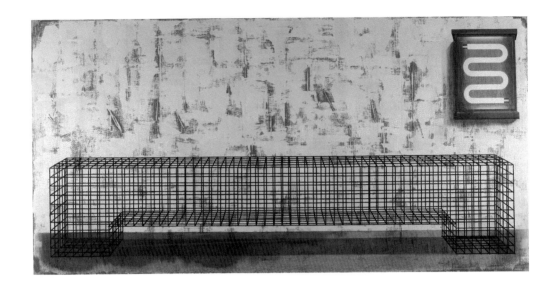

Michael Simpson

# Henrietta Simson

## Giotto's Template

2008
Oil and pigment on gesso board
48 x 60.5 cm

I select early Renaissance depictions of space; landscapes that provided the background (supplement) to a scene or story (argument). The landscape elements were secondary and were employed to frame the narrative. I change the format and scale and remove all narrative elements, freeing the spaces from their historical context. This translates the landscapes into a contemporary framework, thereby allowing a direct engagement with them. These alterations and omissions let the landscapes exist as discrete creations rather than subsidiary to the stories they frame. This particular painting is taken from one of Giotto's frescos in the Magdalene Chapel in the Lower Basilica in Assisi. The title refers to Giotto's technique of repeating this landscape motif in several works in the chapel and also to the fact that his work is considered a model in the development of Renaissance painting, marking the beginning of a certain way of seeing.

My paintings show these landscapes removed from their original context. They are painted using traditional materials, but stop short of being identical in their material application. They have travelled from the early Renaissance to the present, acting as counterpoints to our modern visuality, posing a question for the way we see and represent space.

## Biography

Born in Crawley in 1971, Henrietta Simson attended UWE Bristol 1990-93 and The Slade School of Fine Art London 2005-07 (commences MPhil/PhD 2010). Group exhibitions include *Jerwood Drawing Prize 2005* Jerwood Space London (touring), *Bloomberg New Contemporaries* A Foundation (Liverpool Biennial) & Rochelle School London 2006, *spaces/places/senses/places/senses/*

*spaces* (with Jo Volley) Visual Arts Centre Portsmouth Virginia 2009, *Lulled into Believing* (with Esther Teichmann) Man&Eve London 2009 and *The Borrowed Loop* Man&Eve 2010. Solos include *Drawing and Painting* Slade Summer School 2007, *Over the Frontier* Man&Eve 2008, *Lost Narratives* Slade Research Centre 2008 and presentation in *Volta NY* (Man&Eve) New York 2010.

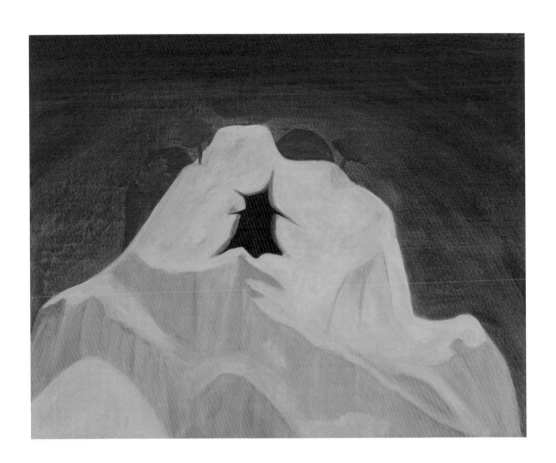

Henrietta Simson

# Veronica Smirnoff

## Lubo

2009
Tempera on wood
69 x 50.5 cm

I use the traditional medium of egg tempera to paint onto gessoed wood panels. This ancient technique is historically associated with Russian and Greek icon painting and is still employed by the Orthodox community.  My work references the aesthetic and allegorical traditions of this visual culture. It maintains a symbolic appearance which is disrupted by the incorporation of imagery and stylistic elements from other sources, including early Renaissance and miniature painting, folk art, cartoons, the media and contemporary fashion.  My working process is influenced by themes of transition, displacement and belonging, altered memories charged with personal experience of the complexity of present-day global reality. Painting becomes a playground for imagination, challenged by the socio-political and spiritual aspects of human existence.

Through the jarring and synthesising of cultural and commodity identities, the present and the past often give way to a more nostalgic feel verging on the esoteric, not consciously following a particular narrative.  The process of surface construction reveals the technique through the qualities of the material, leaving certain layers bare and building up the transparency and volume as well as detailed areas of clothing and headdresses.  For me, borrowing from historical languages becomes less about appropriation and more about intuition, engendering an emotional, critical and cognitive sensibility.

## Biography

Veronica Smirnoff was born in Moscow in 1979. She attended Wimbledon School of Art London 1998-99, The Slade School of Fine Art London 1999-2004, The Academy of Fine Arts Vienna 2001-02 (scholarship) and the Royal Academy of Arts London 2004-07. Her group shows include *Passed as Present* York Art Gallery 2008, *Invasion/Evasion* Baibakov Art Projects Moscow 2008, *Gothic* (Contemporary Art Society exhibition and auction) Sotheby's London 2009, *Women to Watch* Christie's London 2009 and *BRIC* auction Saatchi Gallery London 2010. Solo projects are *Morozka* Galleria Riccardo Crespi Milan 2008 and *Zhar* Galerie Stanislas Bourgain Paris 2010.

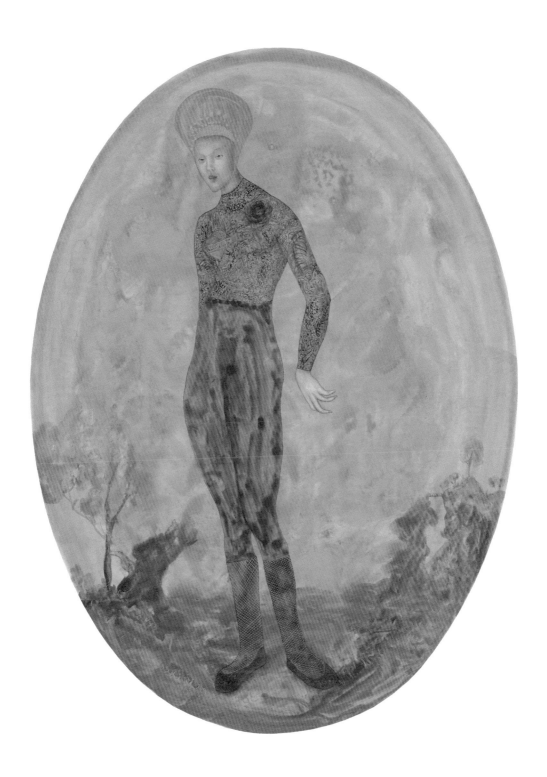

Veronica Smirnoff

# Ian Peter Smith

## Matter at the Edge

2009
Enamel on oil on plywood
80 x 80 cm

*Matter at the edge* is one of a series of works that uses a chance construct of a waveform generated by rolling a lemniscate, the lateral figure of eight form used in modern mathematics as the symbol for infinity, along a line. The waveform is sited within a 20-grid matrix and is reconstructed on the surface of the work using an icosahedron die. The results show both sections of the waveform and the necessary blanks which make up the matrix.

I have developed this process to explore a quantum aspect of making work, to tackle some of the beautiful but difficult concepts of theoretical particle physics.

This particular painting is involved with dark matter and 'brane' theory. *Matter at the edge* looks at how matter and dark matter might work at the very edge, or membrane, of our expanding universe. Conversely, this holds true at an atomic level, by showing how 'strong force' might work with quantum chromodynamics to map the trace of subatomic particles.

My practice as an artist explores the essential relationships and ideal possibilities of space within matter and matter within space.

## Biography

Ian Peter Smith was born in Kingston-Upon-Thames in 1964. He studied at Kingston Polytechnic 1983-84 and Sheffield City Polytechnic 1984-87. His work has been in group exhibitions including *Resonance* Ramsgate Library Gallery Ramsgate 2003, *Abstract Light* Outfitters Gallery Margate 2004, *Margate Rocks* Margate 2004 and *Turner Contemporary Open* Turner Contemporary Project Space Margate 2009. Solo shows include *Drawings* Tom Allen Centre Gallery London 1991, *Sculpture* Café Gallery Projects London 1998, *Scarborough Works* Scarborough Art Gallery 2005 and *Ocean Matrix* Marlowe Theatre Canterbury 2005.

Ian Peter Smith

# Geraldine Swayne

## Industrialist on Wheels

2009
Oil on linen
128.5 x 106 cm

*Industrialist on Wheels* is from a recent series of paintings triggered by photographs of obscure Victorian industrialists. When I look at early photographic portraits I can be captivated by a particular mood or light and will then spend hours fantasising about the back-story or personalities of the sitters.  As Scorsese says,
"The most interesting and exciting thing in the whole world is the human face."

My industrialist has been rendered somewhat helpless by being mounted on wheels, on which he can only trundle towards an impotent and infantilised destiny. Like many of today's bad capitalists I felt he should be ridiculed for his vanity.

I wanted the paintings in the series to appear to emerge like images from chemical baths; or to seem to have occurred organically like mould on confectionary, rather than to look like they had been painted.  This is in a way similar to the alchemic process of silver-gelatine or albumen printmaking.

The effortless look never happened easily and I often felt like a chemist when I worked on the series. There were many exasperated failures. The survivors however, including *Industrialist on Wheels*, hopefully have an autonomous and out-of-time atmosphere and a mysterious internal narrative.

## Biography

Born in 1965, Geraldine Swayne studied at Newcastle University 1985-89. She worked as a special effects designer 1991-2005. London group exhibitions include *Fresh Air Machine* Calvert22 Gallery 2008 (co-curator), *Free Art Fair* Barbican Gallery 2009 and *East End Promise* Red Gallery 2010. Live painting and drawing shows with German group Faust include Wrexner Centre Ohio USA 2009 and Detroit Museum of Contemporary Art USA 2009. Solo projects include *'East End'* (IMAX film) London Film Festival 1999, *Cracks in Time* L-13 London 2007, *Squeeze-Box* NO:ID Gallery London 2009. A collaboration with poet/singer Lydia Lunch is forthcoming at L-13 in September 2010.

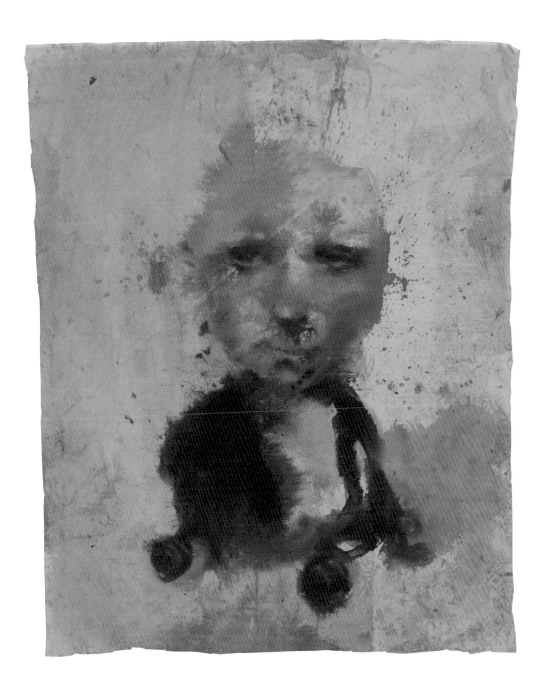

Geraldine Swayne

# Jason Thompson

## Refractions (Robert Hooke)

2010
Enamel paint and varnish on plywood
33.7 x 28 cm

My paintings are usually made of many layers. Each new layer continues, contradicts or buries the previous layer.

I try hard not to start out with any ideas or particular intentions but I'm sure this is not possible.

The gaps in time between layers mean that I get distracted. I lose my thread, but pick up another when the next layer starts. Maybe it's more accurate to say that instead of having no ideas the painting is filled with dead ones.

Parts of the painting are copied, mirrored or echoed in other parts. These copies are then re-copied and so on, again and again.

Structures are formed by this feedback process and it is as though the painting begins to paint itself.

I like to imagine all this is analogous in some way to the natural evolutionary processes by which living things are formed and consciousness is developed. This is probably an illusion but that may be the point.

## Biography

Jason Thompson was born in Liverpool in 1970 and currently lives and works there. He studied painting at Chelsea College of Art and Design London both for his BA (1990-93) and MA (1993-94). He was shortlisted for the *Swiss Bank Corporation European Painting Prize* 1994. He has had works in several group shows including *TEN* Loop Gallery Liverpool (Liverpool Biennial) 2004 and *Overview* at Cornerstone Gallery Liverpool 2007.

Jason Thompson

# Christian Ward

## Frontier Monument

2009
Oil on linen
205 x 221 cm

A teacher once told me that making a painting was like overfilling an envelope. Overlaying subjects, references and styles is a good way to fill up a canvas. I play Walt Disney with black holes or cherry blossoms with an atom bomb afterglow. Each part rhymes with another in dissonance or harmony, sometimes both, and new possibilities open up. A painting is normally finished on a climax, usually about 4am.

## Biography

Born in Noda, Japan in 1977 Christian Ward attended Winchester School of Art 1996-99, Parsons New York 1998 and the Royal Academy Schools London 1999-2002. Group shows include *The Future Lasts a Long Time* Le Consortium Dijon 2005, *Ideal Worlds* Schirn Kunsthalle Frankfurt 2005, *Eat Me, Drink Me* The Goss Michael Foundation Dallas USA 2009, *Elements of Nature* Frederick R. Weisman Museum Malibu USA 2009 and *The Library of Babel / In and Out of Place* Projectspace 176 London 2010. Max Wigram Gallery London solos are *Inside the Island* 2003, *Black Sun* 2005, *Foothills* 2008, and one forthcoming in 2011. *Balanced Rock* was at Galerie Michel Rein Paris 2010.

Christian Ward

# Index of artists

National Museums Liverpool can not be held responsible for the content of external websites

**Cornelia Baltes**
Flat 51
The Forum
Digby Street
London
E2 0LR
www.corneliabaltes.com

**Jon Braley**
41 Furmston Place
Leek
Staffordshire
ST13 6PB
www.jonbraley.com

**G L Brierley**
55 Lansdowne Drive
London Fields
London
E8 3EP
www.glbrierley.com

**Deborah Burnstone**
25 Lucerne Road
London
N5 1TZ
www.deborahburnstone.com

**Darren Coffield**
84 Portland Road
Bromley
Kent
BR1 5AZ
www.darcoff.com

**Keith Coventry**
c/o Ben Tufnell
Haunch of Venison
6 Burlington Gardens
London
W1S 3ET
www.haunchofvenison.com

**Edward Coyle**
4 The Old Green
Horton-cum-Studley
Oxfordshire
OX33 1AT
www.edwardcoyle.co.uk

**Theo Cuff**
Top Floor
41 Hebron Road
Bedminster
Bristol
BS3 3AE
www.axisweb.org/grCVFU.aspx?
SELECTIONID=19830

**Stuart Cumberland**
Flat One
2/4 Venn Street
Clapham Common
London
SW4 0AT
www.theapproach.co.uk
www.stuartcumberland.net

**Ian Davenport**
c/o Waddington Galleries
11 Cork Street
London
W1S 3LT
www.waddington-galleries.com

**Philip Diggle**
498 Archway Road
London
N6 4NA
See YouTube films: *Luxury,
The Camden Chronicles*

**Tim Ellis**
Flat C
44 Elderfield Road
Hackney
London
E5 0LF
www.timellis.org

**Geraint Evans**
5 Robins Court
Birdhurst Road
Croydon
Surrey
CR2 7EE
www.geraintevans.net

**Adam Fearon**
184 Brick Lane
London
E1 6SA
www.adamfearon.com

**Damien Flood**
53c Loughborough Park
London
SW9 8TP
www.greenonredgallery.com

**Nick Fox**
30 Ethnard Road
Peckham
London
SE15 1RU
www.nickfoxart.com

**David Fulford**
53 Camberwell Grove
Camberwell
London
SE5 8JA
www.david-fulford.com

**Mikey Georgeson**
Incident Room 2
The Old Police Station
114 Amersham Vale
London
SE14 6LG
www.mrsolo.info

**Chris Hamer**
12 Leedale Street
Levenshulme
Manchester
M12 5SH
www.chrishamer.org.uk

**Andy Harper**
8 Ilfracombe Flats
Marshalsea Road
London
SE1 1EW
www.andyh.net

**Richard Harrison**
36 Southwell Road
London
SE5 9PG
www.richardharrisonart.com

**Sigrid Holmwood**
c/o Annely Juda Fine Art
4th Floor
23 Dering Street
London
W1S 1AW
www.sigridholmwood.co.uk
www.annelyjudafineart.co.uk

**Phil Illingworth**
28 Rochester Road
Southsea
Hampshire
PO4 9BA
www.philillingworth.com

**Lee Johnson**
Studio F12
38-40 Glasshill Street
London
SE1 0QR
www.leeajohnson.com

**Neal Jones**
32b Elder Avenue
Crouch End
London
N8 8PS
www.grottoidiotto.dearnealjones.
co.uk

**Joseph Long**
27 Sylvan Way
Sea Mills
Bristol
BS9 2LG
www.josephlong.net

**Elizabeth McDonald**
Glasgow
Scotland
www.aesthetiac.com

**Nicholas Middleton**
53 Montague Road
Hackney
London
E8 2HN
www.nicholasmiddleton.co.uk

**Michael Miller**
43 Macclesfield Road
Buxton
Derbyshire
SK17 9AG

**Matthew Mounsey**
16 White Cliff House
Vermont Road
Wandsworth
London
SW18 2LH

**Jost Münster**
94 Greenwood Road
London
E8 1NE
www.jostmuenster.net
www.museum52.com

**Cara Nahaul**
71 Cambridge Road
St. Albans
Hertfordshire
AL1 5LF
www.caranahaul.co.uk
www.silentcity.org.uk

**Narbi Price**
2 Stratford Grove Terrace
Newcastle Upon Tyne
Tyne & Wear
NE6 5BA
www.narbiprice.co.uk

**Steve Proudfoot**
477 Parrs Wood Road
East Didsbury
Manchester
M20 5QG
www.steveproudfoot.co.uk

**Sabrina Shah**
Orchard Farm
Whitford Bridge Road
Stoke Prior
Bromsgrove
Worcestershire
B60 4HD
www.sabrinashah.com

**Annabelle Shelton**
4 Marina Drive
Wolverton
Milton Keynes
Buckinghamshire
MK12 5DW
www.annabelleshelton.com

**George Sherlock**
'Nuns Yard'
83 High Street
Harrold
Bedfordshire
MK43 7BJ

**Michael Simpson**
The Old Gas Works
Frome Road
Bradford on Avon
Wiltshire
BA15 1LE
www.michael-simpson.co.uk

**Henrietta Simson**
Flat 5
6 Glading Terrace
Stoke Newington
London
N16 7NR
www.henriettasimson.com

**Veronica Smirnoff**
10a Wimpole Street
London
W1G 9SS

**Ian Peter Smith**
32 Regent Street
Whitstable
Kent
CT5 1JF
www.ianpetersmith.com

**Daniel Sturgis**
124 Gordon Road
London
SE15 3RP
www.danielsturgis.co.uk

**Geraldine Swayne**
330B Old Ford Road
London
E3 5TA
www.re-title.com/artists/geraldine-swayne.asp
www.geraldineswayne.co.uk

**Jason Thompson**
21 Ventnor Road
Wavertree
Liverpool
Merseyside
L15 4JF
www.iamjasonthompson.com

**Christian Ward**
21 Time Square
London
E8 2LT
www.maxwigram.com/artists/11/

# John Moores Painting Prize Shanghai

# The jury

**Zeng Fanzhi**
Artist

**Gu Wenda**
Artist

**Lewis Biggs**
Director, Liverpool
Biennial

**Peter McDonald**
Artist and former
John Moores first
prizewinner

**Peter Jenkinson**
Cultural Broker

# Preface

**By Wang DaWei**
**Executive Dean of Shanghai University, Fine Arts College**

2010 is a year of miracles. Shanghai is hosting the World Expo and is the focus of a global spotlight. At the same time, the *John Moores Painting Prize*, arguably the most prestigious contemporary art competition in the UK, lands in Shanghai in 2010. Once the 50 year old competition was announced in China, there was a quick and active response throughout the mainland. Within a short span of three months, there were more than 1,100 entries from Shanghai, Beijing, Guangzhou, the Inner Mongolia autonomous region and from many other Chinese provinces and cities - a truly unprecedented occasion. And from now on, the *John Moores Painting Prize* will become a biennial contemporary art event in China.

It is thanks to Lewis Biggs' passionate recommendation and patient negotiation that the *John Moores Painting Prize* is able to be held in Shanghai. His wisdom and attention to detail, his acuity and carefulness together with his familiarity with, and enthusiasm for, Chinese contemporary art touched me greatly. When I first met him it felt just like greeting an old friend. At the local art college here in Shanghai, we have a responsibility to give direction to contemporary Chinese painting, and to foster its healthy development. After several discussions, we arrived at the intention of introducing the *John Moores Painting Prize* to Shanghai, and soon gained the co-operation of James Moores and the John Moores Liverpool Exhibition Trust.

Chinese contemporary art has now undergone 30 years of exploration and development since the policy of reform and opening-up. From opposing to widening-out, from imitating to rethinking: now it is time to settle down and seriously discuss issues of identity and future direction – the 'who am I ?' and the 'where am I going?' of contemporary art in China. Therefore, this is exactly the right time and the right place to introduce the *John Moores Painting Prize* to Shanghai: it is an almost inevitable development for Chinese contemporary art.

The *John Moores Painting Prize Shanghai* will embody the ethos and values of the John Moores Liverpool Exhibition Trust – namely to discover, cultivate and support the work of artists who create new paintings with a diverse range of modern materials and media. The Prize will uphold

the working philosophy, judging criteria and procedures to ensure the professionalism, openness and fairness of the competition. And based on these principles, this is a good opportunity for further improving our domestic competition processes in China.

One aim of this competition is to introduce the richness, colour and diversity of Chinese contemporary art to the world, helping overseas artists to understand various aspects of Chinese contemporary art and improving cultural exchange between China and the UK and even around the world.

Meanwhile, through academic exchanges and the dialogue between the Chinese and British parties on the Shanghai jury, there will be further benefit to Chinese contemporary art criticism and the development of theory, so as gradually to establish a new critical system for contemporary painting in China. Consequently, this cooperation will create a brand new model for exchange and dialogue between China and the UK in the field of contemporary art. And it will also provide a new paradigm for critical literature and for academic standards in Chinese contemporary art education.

This is the very first time that the *John Moores Painting Prize* has been held in Shanghai, and it could be a powerful source of transformation of the long tradition of Chinese painting in a contemporary, global context. As the Prize becomes established, against the backdrop of contemporary cultural development in China, and in a market of 1.3 billion people, it will acquire a deep historical influence. More important still, the success of the *John Moores Painting Prize* could be replicated in any other country, especially in so-called developing countries. The conception and the organisation of the Prize, and this effort to promote exchange, respect and integration between different cultures, will motivate the development of painting in all its diversity and contemporaneity. And that is exactly the original intention of the *John Moores Painting Prize*.

# The magic ingredient - what you see is what you get

## By Lewis Biggs
## Director, Liverpool Biennial

I first began to visit Liverpool as a place to see contemporary visual art in the early 1980s. The Bluecoat Arts Centre and Open Eye Gallery both organised exhibitions for national touring, and the Walker Art Gallery sponsored residencies for artists (at the Bridewell Studios), among whom were Ian McKeever and Anish Kapoor, artists whose work I had already promoted at Arnolfini Gallery in Bristol. The Walker also worked closely with Peter Moores in organising his *Liverpool Project* exhibitions, which attracted national attention and took place in the alternate year from the *John Moores Liverpool Exhibition* (as it was then known), inaugurated in 1957. Through the 1960s and '70s the *'John Moores'* had become by far the most significant art competition in the UK, and it has remained pre-eminent (at least as regards painting) despite competition from others, such as the *Turner Prize*, founded 1984. For me, as for many colleagues, the *John Moores* was an essential reason to visit Liverpool at least every other year.

So it wasn't surprising, when I took up the post of Curator of Exhibitions at Tate Liverpool, that our discussions in the Gallery (it opened in 1988) were influenced by the respect we had for the *John Moores* and for the audiences that it drew from across the UK. The value to Liverpool of the exhibition was similarly recognised by James Moores (great nephew of Sir John Moores, its founder) when in his turn he founded *Liverpool Biennial* as a means of promoting, complementing and adding value to the *John Moores* - and it still remains at the heart of the wider festival a decade later.

In 2000, shortly after I resigned as Director of Tate Liverpool (and a Biennial Trustee) in order to become the full-time Director of *Liverpool Biennial*, I visited the first *Shanghai International Biennale*. The second *Liverpool Biennial* took place in 2002, opening in the same month as the second *Shanghai Biennale*. This coincidence, along with their status as sister cities, encouraged me to try to create stronger links between the visual arts of Shanghai and Liverpool. There's been a good deal of visiting in each direction by artists and curators, and in 2006 our biennials exchanged exhibitions.

But in 2009 the exchange intensified with the help of the Visiting Arts / Cultural Leadership Programme (International Exchange Placements). This supported a

three-month stay at Shanghai University by my colleague Raj Sandhu; and Professor Ling Min, Director of Overseas Arts Projects at the College of Fine Arts, Shanghai University, spent three months based at *Liverpool Biennial*. Professor Ling Min took this opportunity to get to know colleagues in several of the main art and education institutions in Liverpool, and identified a number of projects leading to ongoing cultural exchange. It was her suggestion that the successful and long-proven process that generates the *John Moores* could be replicated in China; and Wang DaWei, her Dean, supported the idea by making organisational and financial resources from the University available.

Professor Ling Min lectures in Art History and Curatorial Studies, and the adoption of the *John Moores* process by Shanghai University is a well-conceived curatorial experiment: there is nothing in the process that is specific to the 'culture' of Liverpool or the UK; it's one form of 'good practice' (among others) regardless of cultural specifics.

What is the magic ingredient of the *John Moores*, its generic power, that makes it possible to apply the same formula in different cultures? I was a juror for the *John Moores 17* in 1991: it was only by participating that I learned the full significance of the process. The unusual (possibly unique) characteristic of the *John Moores* is that the judging is done anonymously. Most of our judgements about art are made on the basis of what we know rather than what we see. We are influenced by knowing that an artist's work commands high prices in the sales room; that it has been shown in a prestigious museum; that it's been bought by this or that collector or dealer; that it was reviewed favourably (or not) by a famous critic or 'personality'; that it hangs in the house of someone who has political influence. Above all, maybe the artist is someone we like (or don't like), or someone to whom we owe a favour. In most art competitions, these are the factors that influence the judges' decisions. Anonymous judging renders irrelevant all these factors. Instead, the judges have to rely on their eyes, informed, of course, by their general knowledge of art. What you see is what you get.

It's this that makes the *John Moores* so popular with artists who are trying to 'break in' to the art milieu, as well as with

the general public. The supposition is that the art has been judged 'on its own merits' by experts who are 'seeing' exactly what the general public sees. Every viewer is able to compare his or her own ability to assess value in art directly with the ability of the jurors.

There is a second characteristic of the *John Moores* that is closely connected with the approach: 'what you see is what you get'. Five jurors means that there are five points of view about what kind of art is most significant at a given moment. (Provided the jurors have not been selected to represent a single polemic). If the jurors respect each other's point of view, this means the final selection will show variety, and will also represent better overall quality of the art than a show selected to be a polemic.

Cultural polemic produces cultural uniformity. Most of us believe that diversity is preferable to uniformity in every way, and so polemical exhibitions tend to be composed of poor quality art. To make this point clear, imagine the paintings as fruit. How boring to have just one kind of fruit! How much more interesting to have many kinds. But in judging quality, no-one compares apples

with pears - we compare apples with apples and pears with pears. If you are polemically in favour of apples, you discard all the pears (however wonderful those pears are). But if you keep the variety of fruit but discard the poor examples, you are left with the best pears and the best apples, (rather than a polemical bowl full of apples, good and bad). The *John Moores* judging process begins by comparing paintings of the same kind, and ends by discarding all but the best of each kind. Provided the five jurors have five different points of view, then you get just the very best paintings in the view of each juror, with no second rate paintings included!

Having been honoured now to be a juror in the first *John Moores Painting Prize* in China, I have been surprised how smoothly this process was replicated in a different cultural situation. The judges, looking hard at the quality of the work in front of them and unencumbered by those 'additional' conceptual meanings of the work suggested by a knowledge of the artist's name and status, were able to agree without much difficulty as to which paintings were 'the best'. It will be fascinating to see whether the paintings from the UK competition shown in

Shanghai, and the prizewinning Chinese paintings shown in Liverpool, are appreciated by the general public as enthusiastically as they have been by the judges. I strongly suspect that they will be.

Lewis Biggs, June 2010

# First prizewinner

# Han Feng

# Han Feng

## Big Plane

2008
Acrylic on canvas
150 x 200 cm

The big aeroplane has exaggerated the proportions of the real one. I want to make a bigger, prettier and disturbed virtual world. This painting is something about dream-making, about the story of sailing and searching in such a paradoxical world.

## Biography

Han Feng was born in Harbin in 1972. He graduated from the Fine Art College Harbin Normal University 1998 and the Fine Art College Shanghai University (Masters) 2009. His exhibitions include *The Backup for New Art (the post-'70s artists' exhibition)* Beijing 2000, *Shanghai Youth Art Exhibition* Liu Hai Su Art Museum Shanghai 2005, *Chinese Painting Exhibition* Museo Della Permanente Milan 2008, *Creative M50* (special jury prize) Shanghai 2008 and *2009 Star of Epsite/Epson photography studio* (judge's award) Epsite Shanghai. His solo exhibition *More Mistakes, More Beautiful* was at Don Gallery Shangai 2009.

Han Feng

# Zou Tao

## Excrement Factory

2008
Oil on canvas
140 x 170 cm

The relationship between excrement and the factory appears absurd, but it seems to have some similarities. The human body is just like an endless working machine, producing material and non-material finished products. It repeats this production and reproduction cycle, constantly evolving. It greedily devours all that which can be devoured and produces everything that can be produced. No matter how we evolve, there is always something ugly and unpleasant, just like excrement. People hate excrement but we cannot get rid of it. I liken it to ready-made ideological waste and try to explain this in my painting.

## Biography

Zou Tao was born in Shenyang in 1984. He studied at Luxun Academy of Fine Arts 2005-09 and now works as a professional painter. His exhibitions include *China Art Prize* (awarded prize for excellence) Artscene Warehouse Shanghai/Beijing 2007, *Limpidity* EM Art Gallery Seoul Korea 2008, *Set Sail* Luxun Academy of Fine Arts Shenyang 2009, *Art, Northeast of China* Weilan Art Museum Shenyang 2009, *China Art Prize* Duolun MOMA Shanghai 2009 and a solo exhibition, *Zoutao* at Artscene Warehouse Shanghai 2009.

Zou Tao

# Zhang Wei

## The Emperor Mountain

2010
Mixed media on canvas
200 x 480 cm

My work originates from a series of random fragments, rather than suddenly coming into being. I follow my emotions, innovations and developments and I try to retain some of the visual experiences that I've gathered, even though some of this experience ends up as mere dust.

My painting represents reality, but not an exact one. Its starting point is a chance encounter with text. In an interactive process, after experiencing 'actually being there', and being caught on film, the audience can make collages with the images according to their own wishes. The images are then reorganised and transferred to the canvas in a violent fashion. Transformed by these different media, the details of the picture become blurred and images eventually form on the canvas. The formal, clear concept disperses, resulting in an effect without cause.

## Biography

Zhang Wei was born in the Inner Mongolia Autonomous Region in 1985. He studied at China Academy of Arts 2003-07 and 2007-10 (Masters) and in 2009 attended Accademia Belle Arti Roma Italy. His exhibitions include *Green Land - Dialogue Between Wind and Land* (solo) Academic Space Hangzhou 2004 and group shows *Stars of the Century - The First Oil Painting Exhibition* Art Museum of China Academy of Art [AMCAA] Hangzhou 2005, *Academic Journey* AMCAA Hangzhou 2007, *The First Young Artists Invitational Exhibition* Han House Hangzhou 2008, *Century Star-The 4th Oil Painting Exhibition* AMCAA Hangzhou 2009, *Excellent Graduation Exhibition of China Academy of Art* AMCAA Hangzhou 2010.

Zhang Wei

# Zhang Zhenxue

## Peach Blossom

2010
Oil on paper
109 x 158 cm

I want to display the charm of the oil colour on a smooth, white surface. White cardboard is the medium I selected to use. The natural beauty of the oil paint presents elegant colours once combined with the reflective white background. My visual language is the expression of a representational object in an abstract way, and it involves some of the traditional methods of Chinese art. Sex is one of the main themes that concern me. From the standpoint of an Asian person, I want to illustrate the sensual element of sex and evoke deep contemplation.

## Biography

Zhang Zhenxue was born in Heilongjiang in 1982. He graduated from Sichuan Fine Arts Institute (decorative art) and is currently studying in the oil painting department of the Institute. His exhibitions include *The 2nd National Lacquer Exhibition* Guangzhou Art Museum Guangzhou 2007, *Freshman: To the Place Where There Are Less Bubbles* Blue Space Gallery Chengdu 2009, and in 2010 *Red River Art* Taiwan, Chongqing, Kunming and Chengdu, Mengzi Museum, *Over The Foul Line* Tankloft Chongqing Contemporary Arts Centre Chongqing, *'Initial Shares' Huang Jueping New Artists' Exhibition* Chang'an Art Museum Chongqing and *The First Round* (artworks from eight post-graduate students) 108 Art Space Chongqing.

Zhang Zhenxue

# Li Zhouwei

## Where are we from? Where will we go?

2009
Ink on rice paper
140 x 200 cm

What is life? Where is the beginning and end of life? What is our destination? We are human blanks, waiting.

## Biography

Li Zhouwei was born in Henan Province in 1973. She graduated from the Chinese Painting Department Guangzhou Academy of Art in 1998, completing a Masters there in 2002. She lectures at Guangzhou Academy of Art and paints at the Youth Painting Institute there. Exhibitions include *3rd Chinese Painting Exhibition* Guangdong Province 2002, *4th Chinese Painting Exhibition* (bronze prize) Guangdong Province 2005, *30th Anniversary of the Reform and Opening Up Policy National Art Exhibition* 2008, *Hundred Years of Fortune* Guangdong Province 2008, *PRC 60th Anniversary Art Exhibition of Guangdong* 2009 and *Open Expression Shanghai Youth Art Exhibition* 2009.

Li Zhouwei

# John Moores Painting Prize: previous main prizewinners

(Unless otherwise stated, these works are now part of the Walker Art Gallery's collection)

1957
**Jack Smith**
Creation and Crucifixion

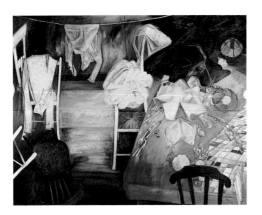

1959
**Patrick Heron**
Black Painting, Red, Brown and Olive, 1959
*location unknown*

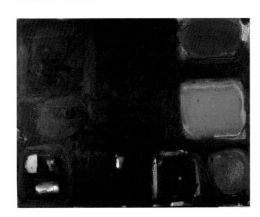

1961
**Henry Mundy**
Cluster
*Bristol Museum and Art Gallery*

1963
**Roger Hilton**
March 1963

1965
**Michael Tyzack**
Alesso B

1969 (joint winner)
**Mary Martin**
Cross

1967
**David Hockney**
Peter Getting Out of Nick's Pool

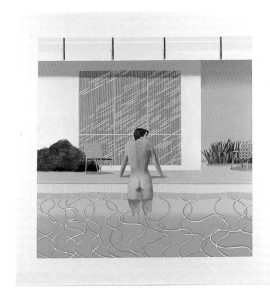

1969 (joint winner)
**Richard Hamilton**
Toaster
*location unknown*

1974
**Myles Murphy**
Figure Against a Yellow Foreground
*location unknown*

1972
**Euan Uglow**
Nude, 12 regular vertical positions from
the eye
*University of Liverpool Art Collection*

1976
**John Walker**
"Juggernaut with Plume - for P. Neruda"
*location unknown*

1978
**Noel Forster**
A Painting in Six Stages with a Blue Triangle

1980
**Michael Moon**
Box Room

1982
**John Hoyland**
Broken Bride

1987
**Tim Head**
Cow Mutations

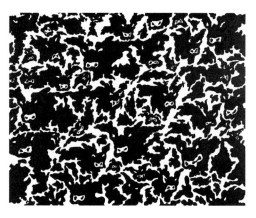

1985
**Bruce McLean**
Oriental Garden

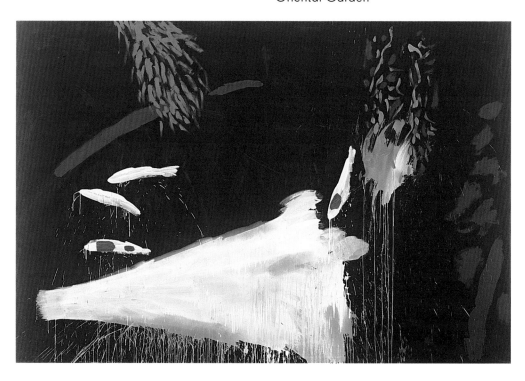

1989
**Lisa Milroy**
Handles

1993
**Peter Doig**
Blotter

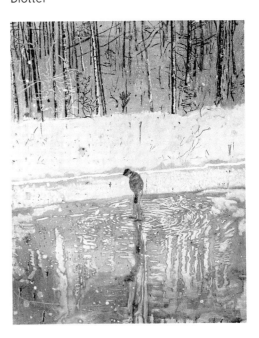

1991
**Andrzej Jackowski**
Beekeeper's Son

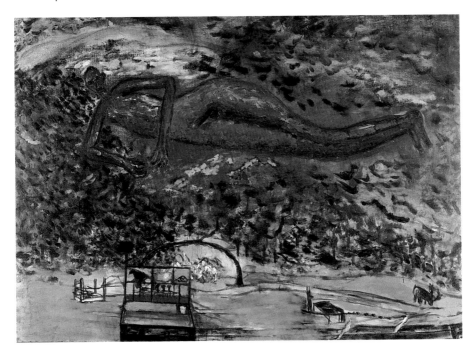

1995
**David Leapman**
Double Tongued Knowability

2002
**Peter Davies**
Super Star Fucker

1997
**Dan Hays**
Harmony in Green

1999
**Michael Raedecker**
Mirage

**2004**
**Alexis Harding**
Slump/Fear (orange/black)

**2006**
**Martin Greenland**
Before Vermeer's Clouds

**2008**
**Peter McDonald**
Fontana

This catalogue accompanies the
**John Moores Painting Prize 2010**
18 September 2010 – 3 January 2011
Walker Art Gallery
William Brown Street
Liverpool L3 8EL

www.liverpoolmuseums.org.uk

Photography: David Flower
Design: Mark Johnson
Editor: Ann Bukantas
Project Manager: Angela Samata
National Museums Liverpool 2010

Catalogue in publication data available
ISBN: 978-1-902700-43-4